N E X U S

THEORY *and* PRACTICE

in contemporary

Volume 2

Bodies of Experience

Gender and

identity

in women's

photography

since 1970

Paul Jobling

scarlet press

For Catherine and Kate, without whom IRIS would not exist.

Published by Scarlet Press
5 Montague Road, London E8 2HN

British Library Cataloguing-in-Publication Data
A catalogue record for this book is available from
the British Library

ISBN 1 85727 009 6 pb

Designed and produced for Scarlet Press by
Chase Production Services, Chadlington OX7 3LN
Typeset from the author's disk by Stanford DTP, Northampton
Colour printing by The Witney Press
Printed in the EC by J.W. Arrowsmith Ltd, Bristol, England

Contents

List of illustrations

All works appear courtesy of the artists.

NEXUS:
Theory and Practice in Contemporary Women's Photography

Bodies of Experience: Gender and Identity in Women's Photography since 1970 is the second volume in the *Nexus* series and is concerned with the relationship between women photographers and the traditions of documentary, portraiture and montage. Paul Jobling demonstrates that women's interactions with the development of photographic history have been multiple and varied as well as critical, if under-represented by mainstream literature on the subject. Focusing on the period from the 1970s to the present, the author details the ways in which women have used photography to pose challenging questions about gender identity and the significance of representation in our society. Taking the medium on its own terms, women photographers have countered and interrogated its 'male-stream' uses in order to find a voice for alternative female and male subjectivities. This second volume in the series continues *Nexus*' aim to explore the relationships between theory and practice in the work of contemporary women photographers and the way in which ideas are transformed into visual praxis.

The history of women in photography is long and complex. Since its inception, photography has been a medium more open to the participation of women as producers than have traditional forms of fine art such as painting and sculpture. Arguably, however, this is not because of any more egalitarian approach to the medium, but because photography itself has an uncertain status as a form of 'art' and ill-defined rules of training and access. There were many early arguments to suggest that its mechanical or technological nature made it more appropriate to science than art or that it would, in fact, destroy the aura surrounding the work of art through mass

reproduction. Its popular and 'amateur' status continues to make it a medium wrought with contradictions as an art form and a certain ambivalence can still be discerned in the very different ways people respond to, for example, mass media photography, personal 'snapshots' and photographs in the art gallery. But it is precisely these contradictions and uncertainties that made it available to women from a very early stage and enabled female practitioners such as Julia Margaret Cameron or Florence Henri to become well known and respected in the late nineteenth and early twentieth centuries respectively when women's professional artistic practice was more generally marginalised.

Furthermore, female practitioners are well represented and well known in very diverse areas of photographic practice. Women have produced successful documentary work, fashion and advertisement photographs, photomontage, portrait work, experimental art photography, installation/video, phototherapy and many alternative forms of feminist political work. This wide base of female participation gives contemporary practitioners a strong history upon which to draw and a powerful foothold in the medium. Additionally, women's historical links to photography were not only through practice. Women have also been engaged in theoretical debates about photography. Practitioners and theorists have written influential texts on the history and theory of photography as well as the practice of women in the field. Again, photography's accessibility as a medium made it more available to women critics and theorists than the more traditional areas of fine art. Women could engage in the debates and challenge the parameters of this less stable form of practice. Because of this, women have helped to shape and define the role of photography through their written as much as through their visual work.

Contradictorily, though, it is as subject-matter that women have their most definitive links with photography. From the experimental photographs of male practitioners such as Man Ray to the ubiquitous 'pin-up', the body of 'woman' is the mainstay of photographic imagery. It is precisely this interconnection between women as producers/theorists and as objects of photography which makes women's contemporary practice a fascinating engagement with the politics of representation. In a society such as ours which is hyper-saturated with 'images of women', women making images are in a unique position to question the significance of representation to issues of gender identity and cultural politics. Their presence and practice disrupts the traditional division between male artist and female model and challenges conventional modes of spectatorship.

Despite women's history as photographers and their strong presence in contemporary practice, it is significant that they are still widely under-represented in mainstream exhibitions, galleries and publications on the subject. Their history remains relatively hidden and their contemporary interventions eclipsed by the work of their male counterparts. This series aims to redress the balance by focusing attention on the particular issues raised by women's practice. The series will tackle a variety of areas, such as women in documentary photography, women's reconceptions of the maternal and the sexual body as well as women's responses to time and space, history and memory. The list is far from exhaustive as women's practice is rich and diverse. However, the themes tackled in the series begin the process of negotiation and exploration demanded by looking at the work. It is imperative that the masculine histories of photography be rewritten in light of women's practice.

Nexus is concerned with the crucial relationship between theory and practice in women's photography which makes it such a rich vein of material to uncover. Thus, the volumes establish a number of

different modes of engagement with women's photography rather than attempting to fix, artificially, a single, exclusive meaning to it. The volumes open up a dialogue between theory and practice without privileging either mode; they are intended to stimulate lively debate through various forms of interrogation. The interdisciplinarity of the series is part of this strategy. The authors are all involved with aspects of critical theory in their own work, but come to this photographic material from different disciplines and with different interests. Some approach the works as historians of art or photography, while others are from philosophy, film or literature backgrounds. Because of this, each author has a unique viewpoint to contribute to the series and there is no dominant, specialist mode of enquiry. The photographs discussed in this series and the themes of the volumes are not meant to exclude non-specialists but to bring this material to new audiences who, perhaps, have not had the opportunity to see this work before.

The same is true of the archival source of these photographs, *Iris: The Women's Photography Project* at Staffordshire University. As the only resource in Britain which exclusively devotes itself to the collection and promotion of contemporary women photographers' work, *Iris* is uniquely situated as a partner in these publications. Since its inception in 1994 in conjunction with the national programme *Signals: Festival of Women Photographers*, *Iris* has brought the work of its membership to light through exhibitions and conferences as well as an internet site, and has burgeoning plans for digital distribution. With continued research and development, the project seeks to make this work accessible and available to the widest possible audience. *Nexus* is part of this initiative to document the exceptional role of women in photography and bring this to increased public attention. The series draws its photographic material from the *Iris* collection and their archival documentation is

the principal source of information about the photographers discussed in the individual volumes. Research on alternative areas of artistic practice and history can be begun only with the help of such resources as *Iris* which run counter to the dominant, institutional modes of collection which are changing very slowly in response to new demands from their users. *Nexus* demonstrates a fruitful collaboration between theory and practice and shows what a rich source of material exists in this pioneering project.

The publisher of this series, Scarlet Press, is similarly concerned with the recovery of women's histories and is itself an example of a feminist intervention into mainstream institutional practices which exclude women. Founded in 1989, Scarlet Press has sought to publish a wide range of books on all aspects of women's lived experience. The books are intended to appeal to both academic and general readerships, thus breaking boundaries between audiences and encouraging more stimulating arguments and debates to take place between everyone interested in the cultural history of women. This series continues Scarlet's feminist intellectual traditions and encourages its expansion into publications on the visual arts.

It is important to mention finally the support given to *Nexus: Theory and Practice in Contemporary Women's Photography* by Staffordshire University. In recognition of the value of the interdisciplinary collaboration of this series and the pioneering use of the resource, the Staffordshire University Research Initiative (through the School of Arts and the School of Design and Ceramics) granted the series the initial funding necessary for its production. The Arts Council further contributed to the costs of the production of high-quality illustrated volumes. It is encouraging to see the involvement of such large institutions in a project such as this and their foresight will be rewarded.

Marsha Meskimmon, Series Editor

Bodies of Experience: Gender and Identity in Women's Photography since 1970

Introduction

> Photography is central to the ideological market-place of capitalist society. But photographs do not simply offer us commodities for vicarious consumption – they also offer us identities to inhabit, constructing and circulating a systematic regime of images through which we are constantly invited to think the probabilities and possibilities of our lives.
>
> (Patricia Holland, Jo Spence and Simon Watney,
> *Photography/Politics: Two*, 1986)

Women have been active participants in the history of photography since the invention of the daguerreotype in the nineteenth century and their contribution has been instrumental in the development of various photographic styles and discourses, from photomontage to photodocumentary, and from landscape to fashion photography.[1] Probably the largest area in which they have had a part to play, however, has been the production of photographic portraits which began in the 1840s when women like Ann Cook, who was working in Leeds, turned to portraiture as a way of keeping their families after they were widowed. This involvement with portrait production continued well into the twentieth century in the independent studio practices of Dorothy Wilding and Vivienne (Florence Entwhistle).[2] Although women have been a significant presence from the outset in photographic practice in Britain,[3] before the intervention of feminism in the 1970s their work was regarded in stereotypical or patriarchal terms. In this way, the female portrait photographer was often thought of as being inferior to or more frivolous than her male

1

counterparts; in 1924, for example, Molly Durelle commented that, for women, 'quite a good income can be made by a season on the Riviera or some fashionable resort'.[4] On another level, it was often commonly assumed that female photographers were biologically conditioned to view the world differently to men. Comparing the photodocumentary images of Walker Evans and Dorothea Lange, for example (two of the most prominent practitioners working for the Farm Securities Administration [FSA] in America as part of F. D. Roosevelt's New Deal reforms), Roy Stryker concluded:

> I respected Walker's pictures for their almost medical precision, their great skill, but they were cool . . . then Dorothea's work came in. I hadn't even met her yet, but . . . I saw a sense – the Mother – the great feeling for human beings she had which was so valuable. She could go into the field and a man working there would look up, and he must have had some feeling that there was a wonderful woman, and that she was going to be sympathetic, and this never failed to show in her work.[5]

While Stryker clearly commended Lange for her humanity, his comments are revealing since they also imply, in somewhat paternalistic terms, that her approach was essentially more emotional and thereby less serious than Evans's. As such, he appears to trade on the Cartesian split between mind and body and the popular mythology which determines the natural world as female or maternal and the intellectual sphere as masculine. For many years it was the idea of the essential maternal which tended to swamp interpretations of Lange's work, a reputation, it has to be said, largely fashioned on the iconic status of her photograph *Migrant Mother* (1936). This gendered inflection has tended also to occlude her own express, political objective to frame subjects in a

temporal context, so as to deal with their sense of place as well as their sense of history: 'Documentary photography', she claimed, 'records the social scene of our time. It mirrors the present and documents for the future. Its focus is man in his relation to mankind.'[6] Moreover, Stryker's suggestion that Lange's sitters were simply mesmerised by the gaze of her lens raises issues concerning the complex spectatorial dynamics between observer and observed and the regime of power between the producer and her subjects. As Lange recalled, the migrant mother 'seemed to know I might do something for her and that she might do something for me'.[7]

It is the intention of this essay, therefore, to examine the contribution of female practitioners to photography since the 1970s and the various ways in which they have transformed both the theory and practice of the medium. Principally, I want to consider how women have deconstructed essentialist or binarist concepts of sex and gender by propounding either new ways of representing subjects, or of thinking about the meaning of identity, or both. Many female photographers have contested the Cartesian split between the (masculine) mind and the (feminine) body, thereby problematising the idea of the essential maternal, and I wish to argue that these photographers have used the medium as a means of negating stereotypical or normative representations of gender, in addition to using it as an agent of empowerment, both for themselves and the subjects they photograph. Consequently, the types of images included in this essay deal with more fluid sex and gender identities, achieved not by supplanting a crudely patriarchal way of looking at the world with a matriarchal one, but by postulating instead a more subtle negotiation of oppositional identities within contemporary fields of dominant or hegemonic power.

In elaborating the contribution of women to photography since 1970, and the impact of feminist theory on it, the discussion which

follows concentrates on the symbiosis between several different photographic formats, namely, documentary, portraiture and montage, while at the same time evincing a cluster of interdependent themes and images for analysis: the workplace, family values, mother and daughter relationships, the formation of an individuated identity, the idea of masquerade, and gender as performance. In turn, a central leitmotiv of this part of my analysis of such images, and crucial to our understanding of them, whether representations of the home, the workplace, the self, or the other, is the pivotal role of the body as a culturally or historically determined construct. Thus, as Foucault has propounded, I wish to analyse the body in such contexts 'as an inscribed surface of events'.[8] The final section of the essay explores the issue of objectification in the context of otherness, the tension between producer and subject, and the implications of the ostensible discrepancy in power between the observer and the observed in terms of class, gender, age and professional status. Here, I wish to assess the extent to which it is at all possible or desirable to transcend the binary opposition between subject and object, between the 'seeing eye' and the 'sentient I'.

Finally, it is worth stating my own investment as a male spectator in analysing such work and issues. On a professional basis, I have been teaching, researching and writing about photography and gender politics for the past twelve years.[9] My interest in such material and issues also emanates, however, from a more personal perspective as a gay man or, more cogently, as someone who also inhabits the margins of power that feminist or 'queer' photographers seek to foreground.[10] In expressing this, I do not intend to infer that femininity and homosexuality can merely be conflated or traduced, or to propose a one-to-one relationship between feminism and queer theory, although the latter both converge in their aim to subvert the hegemony of normative or patriarchal sexualities. I am not just

concerned in this essay, therefore, with photography by women for women, but with a praxis which aims to expand the parameters of cultural production and to dismantle the gender divisions arising from it in ways that are of relevance to everybody. If, as Eve Kosofsky Sedgwick contends, 'When something is about masculinity it is not always about men'[11] then, *mutatis mutandis*, I would claim when something is about femininity it is not always about women.

Taking control: identity, women and photography during the 1970s

> ... in the middle, cadaverous, awful, lay the grey puddle in the courtyard ... I came to the puddle. I could not cross it. Identity failed me.
>
> (Virginia Woolf, *The Waves*, 1931)

A turning point in the role and status of women's photography in Britain occurred in the wake of femininist politics during the late 1960s and the subsequent foundation of a photographic collective centred at the Half Moon Gallery in Whitechapel, east London, in 1972. The original members of the collective included Maggie Murray, Sally Greenhill and Val Wilmer, all of whom had studied photography at the Regent Street Polytechnic (latterly the University of Westminster) and who mounted *Women on Women*, the first photographic exhibition which aimed both to counter stereotypical forms of representation and to give working-class women a platform for cultural production. By 1974, the photographer Jo Spence had also become associated with the collective, now known as the Hackney Flashers and defining themselves as 'socialists and feminists'.[12] The collective worked initially within the tradition of a

realist documentary style, emphasising class issues in travelling exhibitions such as *Women and Work*, originated in 1975. Within the space of a few years, however, they began to question both the facticity and the effectivity of this type of photography and to postulate more creative ways of working with documentary discourse. In this regard, their ideas parallel those of the film-maker John Grierson, who had been responsible for coining the term documentary in 1926 and who subsequently began to qualify its imputed realism in his writings of the 1930s and 1940s, contending: 'My separate claim for documentary is simply that in its use of the living article, there is also an opportunity to perform creative work.'[13] Building on Grierson's aesthetic, the Flashers expressed reservations concerning not just the realist aspects of photodocumentation but also the way that such verisimilitude could hamper a fuller understanding of the ideological implications of the subjects portrayed:

The limitations of documentary photography became apparent with the completion of the *Women and Work* exhibition. The photographs assumed a 'window on the world' through the camera and failed to question the notion of reality rooted in appearances. The photographs were positive and promoted self-recognition but could not expose the complex social and economic relationships within which women's subordination is maintained.[14]

Ever since its invention in the nineteenth century, there has been a strong tendency among many people to regard the photographic image unquestioningly as a slice of reality. Roland Barthes, for example, compounded this perspective and the ontological status of photography as a form of realism in his 1961 essay *The Photographic Message* when he referred to the way that

photographs work at the level of denotation as nothing more than traces or signifiers of reality: 'What is the content of the photographic message? What does the photograph transmit? By definition the scene itself, the literal reality.'[15] In the same essay, however, Barthes raises the idea of the photographic paradox, arguing that while photographs depict only what exists, as much as any other form of representation, their meanings become less obvious according to the context in which they appear. That is, photographs also work at the level of connotation, functioning as signs in which a signifier (the material substance constituting the image, the photographic likeness itself) stands in a symbiotic relation to a signified (a form, idea or concept which we arbitrarily associate with the signifier, as in the case of red roses symbolising either passion or sorrow). As such, photographs work at the level of association or connotation and are replete with cultural meanings or codes we have to interpret: 'All images are polysemous, they imply, underlying their signifiers, a "floating chain" of signifieds, the reader able to choose some and ignore others.'[16]

Several of Barthes' essays, including *The Photographic Message*, were widely available in English translation by the late 1970s and were seminal reading for many photographers attempting to rationalise the interconnected issues of realism and representation.[17] Jo Spence, for example, became intensely interested in theories of realism after she embarked on her degree in film and photography in 1979. In turn, left-wing and feminist producers began to work with more inventive formats so as to underscore the tension between photographic denotation and connotation. The Hackney Flashers responded by exploiting the formal dialectic of montage, juxtaposing their own photographs with images culled from the mass media so as to invite closer scrutiny and analysis of issues intrinsic to most women's daily lives. An exhibition panel entitled *Who's Holding the*

Baby ... and Where? (1977–78), for example, makes a cryptic comment on class and capital by combining, at the top, a photograph of a mother doing the laundry and two children eating a meal in a cramped kitchen, with an advertisement depicting a mother and daughter in a pristine, fitted kitchen, and, at the bottom, an advertisement for property in Belgravia, central London, with a photograph of an East End slum.

In confronting the formal limitations of the photographic medium, therefore, the Hackney Flashers engendered a sharpening of attitudes towards the role of family life and the workplace, and the representation of working-class subjects, encouraging women without any formal photographic training to become active participants in representing their own history. Such concerns were to be later compounded in Jo Spence's phototherapy, which she undertook initially with Rosy Martin, as well as galvanising an entire generation of female photographers to elaborate the form and content of documentary expression with renewed vigour. The aim of these photographers, therefore, was not to dispense with tropes of domestic and female activity but to transform them aesthetically and expand them ideologically. As Joan Solomon has claimed, women must use photography as an empowering tool that enables them to step right into and to cross over the symbolic barrier of Woolf's puddle:

> The point is to remove ourselves from the usual 'happy snaps' of the idealised family and engage with discomforts and conflicts and even crises lying beneath the surfaces of family outings and weddings: in other words, to engage with the psychic reality of our lives.[18]

Women at work

One of the most prevalent themes in women's photography has been the representation of the workplace and the position of women within it. In the first quarter of the twentieth century, Christina Broom and Olive Edis had photographed various professional types, including female police officers and VAD nurses, in their uniforms[19] and in the 1930s, several women photodocumentarians had concentrated on the class structures of various professions; thus Margaret Monck made studies of workers in London as diverse as nannies and market stall holders, while Helen Muspratt travelled to Wales and Russia to document the lives of industrial and agricultural communities.[20] As we have already seen, the class-consciousness of women's work became more politicised in the aims and objectives of the Hackney Flashers, and after the election of Mrs Thatcher in 1979 as the first female prime minister in Britain, interest in the economic role of women intensified. Many women, however, soon felt betrayed by Thatcher's lack of interest in gender politics and, notwithstanding the enforcement of equal opportunities, her party's policies were seen to repress and isolate women rather than to facilitate a role for them outside family life. By 1975, 46.2 per cent of women in OECD countries were working outside the home for a wage, but typically in part-time or low-paid occupations such as clerical, secretarial, nursing, manufacturing and retail.[21] Few women in Thatcher's own administration were given access to positions of power, for instance, and the government's dismantling of the welfare state tended to inhibit women from taking up full-time employment by thrusting the burden and duty of caring for sick and elderly relatives on to their shoulders. Furthermore, as unemployment began to rise to unprecedented levels during the 1980s, many photographers turned their lenses on the division of labour in order to expose

discriminatory practices in the workplace with regard to class, gender and ethnicity.

In 1981 Rhonda Wilson, who during the late 1970s had been employed as a journalist writing the pop music page and answering readers' problem letters in *Jackie*, co-founded Feministo, a network of female artists based in the Midlands and London, while also establishing a reputation as a freelance photographer. Since that time she has used photography from a political perspective to explore various issues such as housing, old age, ethnicity and work, often playing on the representational tension between mass media stereotypes and feminist ideology, as the Hackney Flashers had done before her. Working for the Low Pay Unit of Birmingham City Council in 1986–87, she produced a series of striking images which exploited the format of the advertising hoarding poster to present an oppositional point of view.[22] In *Miss Badly Paid*, for example (figure 1), she deals with the invisible agenda of women's employment by

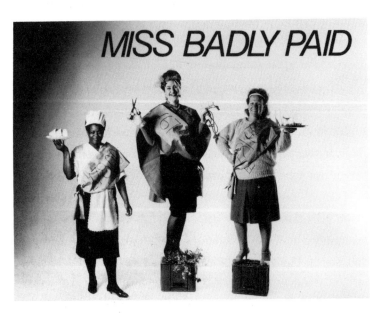

Figure 1 Rhonda Wilson, *Miss Badly Paid*, 1986–87

revealing the material gulf between wages in the ten worst-paid jobs. Here, her subjects have been posed as if they are participants in a spoof beauty contest and the three winners display their typical weekly earnings on their sashes, that is from left to right, £78, £67.40 and £81.60. In the poster, further diegetic details are incorporated – in this instance the addition of a list of the ten worst-paid jobs in 1986–87 to the left of the photograph, and a quote by a 44 year-old hairdresser from Moseley to the right, the latter serving to give working-class women a voice with which they can affirm both their professional power and the pride they take in their labour.

If, as Wilson's portrayal suggests, women must struggle to be taken seriously in jobs which in patriarchal society are regarded as traditionally feminine occupations, Debbie Humphry, as part of her documentary project *Gender Crossings* during the 1990s, has concentrated on those women who have transgressed such ideological gender boundaries by stepping into the domain of 'men's work'. In 1990, a report into the working conditions of professional women for the Hansard Society Commission concluded that women still

face general barriers which transcend differences of occupation and sector – out-dated attitudes towards women's roles in society, sex discrimination, inadequate provision of child care facilities or support for the care of elderly dependents, and inflexibility in the organisation of work and careers.[23]

In iconoclastic and sexually ambiguous photographs such as *Computer Operator with her Male Colleagues* and *Female Fire Fighter in Sleeping Quarters with Male Colleagues* (figures 2 and 3), Humphry represents how women can co-opt patriarchy to their own ends so as to smash through the glass ceiling of discrimination that the Hansard report describes.

Figure 2 Debbie Humphry, *Computer Operator with her Male Colleagues*, 1996

Figure 3 Debbie Humphry, *Female Fire Fighter in Sleeping Quarters with Male Colleagues*, 1996

In the first image, the female computer operator is the central figure, wearing a short haircut and a suit and tie, the traditional formal garb of white-collar male employees. At first glance, we do not immediately discern that she is a woman; the baggy, ill-fitting suit and crossed arms disguise her breasts and her gaze is as direct as those of either of the men who flank her. Nor should we necessarily assume that her choice of masculine attire signifies the fact that she is either a lesbian or a female transvestite. Rather, the photograph represents an androgynous masquerade that subverts both the normative dress codes and the power structure of the workplace, and Humphry portrays fashion as a kind of 'body technique',[24] the visible marker of subconscious desires and fantasies that constitute 'one road from the inner to the outer world'.[25] This play on external appearances, therefore, invites us to question the interior motives for her subject's decision to wear a suit and tie, which is clearly not the same thing as the more accepted post-feminist convention of women wearing trousers. Why should a suit hold any more power if it is worn by a man, for instance, and why should a woman, whether in the same position of power as a man or subordinate to him, not choose to wear a suit to work?[26] While the female worker expresses her right to wear a suit, Humphry also appears to suggest, however, that it is going to take more than this kind of masquerade to effect equality in the workplace. She does not inform us of the exact professional status of the three individuals portrayed, but the woman seems to be overshadowed by her male colleagues and, whereas they are pictured standing, she is resting on a desk with her arms guardedly crossed.

In the second image, the sexual ambiguities concerning what constitutes appropriate jobs for men and women are explored from a different perspective. Here the female fire fighter has been photographed not at work but in the same sleeping quarters as her

male colleagues. The four characters who are represented, however, all appear to be physically and physiognomically of the same sex and there is not a clear-cut case for identifying which of them is a woman. Notwithstanding this ambiguity, all four subjects seem to be equally at ease with the situation and, again, rather than simply trying to maintain that some jobs and workers are exclusively masculine or feminine, or even straight or gay, Humphry deals with more fluid boundaries which resist the idea of a pre-determined or core gender and sexual identity (a point to which I shall return in discussing the performative aspects of Humphry's photographs of gay men and women and transvestites).

Using a different symbolic format, Caroline Molloy also deals with professional stereotypes in her series of portraits entitled *21 Individuals Who Do the Same Job* (figure 4). Here, we are confronted by a gallery of female and male heads from different ethnic backgrounds and age groups, who gaze out

Figure 4 Caroline Molloy, *21 Individuals Who Do the Same Job* (undated)

uncompromisingly at the spectator. Nothing further is divulged about their situation, we do not know their names or ages or where they live and, more importantly, what they do for a living. Instead, Molloy represents each of the 21 individuals in exactly the same way and, consequently, affords them equal social as well as professional status. It is left to the spectator to determine which occupation might be common to these distinct phenotypes, and to question whether gender, race, class or age in the form of outward appearances are accurate barometers of professional status, intelligence and aptitude, or whether they are prejudicial in forming first impressions. Would we think the same of this gallery of individuals, for instance, if we discovered that they were all sex-workers in pornographic films as we would if they were office filing clerks or school teachers? Molloy's psychological play on representation elliptically subverts the concept of the stereotype by inferring that professional status is a superficial unifying factor in most people's lives (we could just as well argue that what she represents are '21 others who do the same job'), while at the same time she appears to invoke Victor Burgin's idea that it is only through appearances that we can negotiate or make sense of our individual and group identities:

We become who we are only through our encounter, while growing up, with the multitude of representations of what we may become – the various positions that society allocates to us. There is no essential self which precedes the social construction of the self through the agency of representation.[27]

The theme of professional discrimination has also been the concern of several contemporary photographers working in colour formats. Although colour is still resisted by many photodocumentarians because of its associations with commercial

and advertising photography – Henri Cartier-Bresson, for instance, has referred to chromatic work as 'trash' and 'murder'[28] – for many others the very vulgarity and artificiality of everyday life can be embodied only in colour photography. These include Martin Parr and Chris Steele-Perkins, who have exploited a garish, colour-rich documentary style to excoriate the British class system and to symbolise the discrepancies in taste and lifestyle which have ensued in British culture since the mid-1980s.[29] Anna Fox has used colour for similar purpose and effect, most notably in her 1987 project *Workstations*, which deals with office life in the south of England. In the 35 images which make up the series, Fox explores the entrepreneurial ethos of Thatcherite Britain by representing the discrepancy in power between men and women as they actually perform at work. Each of the images is accompanied by a statement from a business magazine or text which has been used to illuminate the rampant chauvinism of the workplace.[30] In the sexual dynamics which ensue between professional men and women, the latter are portrayed as a more humane and indispensable force, even though their work is often regarded as subordinate to that of men. Thus, in *Having a Secretary is a Status Symbol*, the division of labour is denoted by the division of space in the photograph, with the male boss represented in the background from behind, and his secretary, seated at her desk, in the foreground of the picture. He, therefore, is the symbol of faceless (male) corporatism, while she is the 'real' individual who performs a holding exercise at the front of the office and whom at the outset most of us would probably encounter, either by telephone or in person.

The work that Karen Goss produced in 1993 forms an interesting counterpart to that of Fox in so far as she often trades on the same kind of iconography and narrative structure, but in displaying her photographs she differs radically and departs from a straightforward reportage style: 'I try to question the dominant cultural traditions of

Figure 5 Katherine O'Connor, *John Duhig, Castlegregory, Co. Kerry, Eire*, 1992

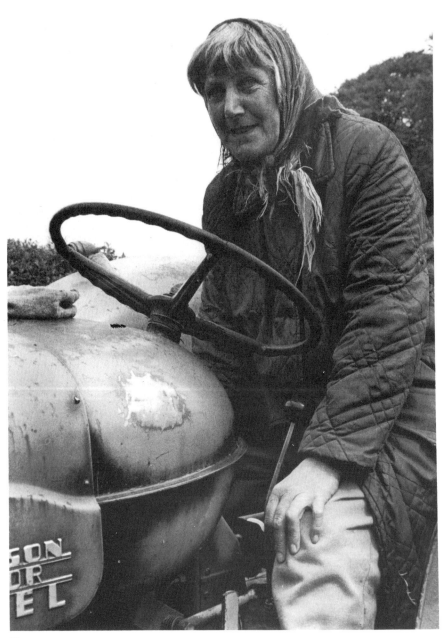

Figure 6 *opposite* Jacqueline Sarsby, *Dartmoor Smallholder on her Tractor*, 1993

Figure 7 Jacqueline Sarsby, *Birthday Party at Aysh Farm*, 1992

representations of the female identity, by reconstructing . . . viewing contexts. This includes the interaction of humour, image and text.'[31] Goss presents these ideas as sequences of three photographs, cut into strips and mounted on rotating panels much like high-street advertising hoardings, that unfold a dialectic narrative by inviting the spectator to turn a mechanical handle. In the series *The Business Meeting*, for example, she sets up a fictional *mise-en-scène* depicting the interaction of a man and woman working in an office. Whereas the business is unspecified, as we move from the first picture of a woman sitting by herself engrossed in her work in front of a computer, to the second which shows her being approached by a man who grasps her shoulder with his hand (figure 8), to the last

depicting her waiting on her own outside a pub at night, the message concerning which type of meeting has been arranged, and the idea of the office as an incubator for sexual relationships and trysts that parallel the discrepancy in power between male and female employees (has she been stood up?), becomes patently visible.

Probably the most difficult balancing act that many working women have to perform lies in combining a job, whether full- or part-time, with the running of a household. Ever since Antiquity, the domestic economy has been regarded as the natural province of women, whose physical and characteristic traits, it was thought, not only predisposed them to motherhood but also, as Xenophon put it, to 'indoor works' in contrast to men whose strength and virility were best suited for work 'in the open air'.[32] Such patriarchal thinking is still in evidence today in the form of familial ideology that emphasises the dual role of women as wives and mothers. We can discern this sexual tension played out in American photographer Katherine O'Connor's exposition of working-class family life in the small, isolated mountain community of Castlegregory, County Kerry, in the south-west of Eire. In figure 5, for example, we see a man tending to his garden, while the interior, domestic sphere of his wife is connoted by the presence of some washing drying on the line. Working with an equally traditional form of photodocumentary narrative, Jacqueline Sarsby's representation of agricultural labour, executed between 1991 and 1993 on several small farms in Dartmoor, Devon, portrays both visually and verbally (exhibitions of these photographs are orchestrated by tape recordings relating the experiences of the subjects in the images) the idea that most women perform a double shift in any working day, carrying out arduous and unglamorous tasks outdoors as well as domestic chores such as the preparation of a children's tea party (figures 6 and 7).[33]

Refiguring the family album

Not only is the home the locus of much of the physical labour undertaken by women, but family life also provides an important arena for the formation and consolidation of both social and sexual identities. In the context of the home, the family album is usually the agency through which we commemorate various rites of passage; births and birthdays, marriages and holidays, all find their automatic place in a leatherbound book or shoebox full of snapshots. For many people, therefore, such photographs serve to authorise and bolster the universal validity of the nuclear family (even though only 28 per cent of contemporary households in Britain consist of a married couple with dependent children), and assume the unassailable and unquestioned status of truth-telling documents, literally describing the different stages in the formation of our social and sexual selves: 'Viewing the "family album" often activates a response of nostalgia – the return "home" to an idealised golden past, free of conflict, where everyone had a place, everyone knew their place and "reality" was real.'[34] This idealistic view of family life, however, tends to edit out any painful or disquieting moments (there are generally no photographs of funerals, for instance, in the family album), and to banish any hint of deviancy or subversion – the naked adult body, or altercations in the family.

In opposition to this, many contemporary female practitioners have used various photographic styles from documentary expression to constructed images to reveal the mythologies of the family album and to uncover how the ritual of family existence has also had a crucial part to play in the evolution of deep-seated, personal traumas and anxieties. In such instances, the body has once more been deployed as a pivotal trope by women photographers to symbolise both the psychological and corporeal aspects that constitute gender

identities, and the imbrication of feminine and masculine attributes. All of the photographers whose work has been included for analysis in this section have represented the body in specific contexts and, in turn, appear to endorse Foucault's writing on genealogy in so far as they negate the idea that gender originates with biology, and rather emphasise the idea that identity is constructed in and by institutions, practices and discourses. As Foucault has demonstrated, in the modern period the body has become a politicised object, a crucial site for the exercise and regulation of power and, hence, is not a stable, unitary entity but a temporal and spatial construction.[35]

A central concern in the work of several female photographers dealing with the family as an institution of power has been the relationships between parents and children and their role in the formation of individuated bodies and psychic identities. In the early 1990s, Jennette Williams began to explore the meaning of motherhood after she and her husband adopted a daughter of their own. On one level, Williams undertook this photodocumentation to help her to objectify her personal feelings of responsibility and awe in becoming a parent, commenting:

> I needed to describe and explore the foreign world of motherhood into which I felt catapulted without preparation. The more I looked at this world of children, of young pregnant mothers and ageing matriarchs, the more I was able to feel about where I came from, where I am, where I may be going.[36]

On another level, however, as Williams intimates, her project acted as a catalyst that enabled her to come to terms with the construction of the self and its psychological origins in childhood: 'An axiomatic connection among us all, regardless of class, is that we all were children, and felt as children feel. I photograph to evoke the

common bond I share with people I don't know.'[37] We can see how Williams has attempted to visualise the 'common bond' which is formed between female subjects in her series of photographs which concentrate on the psychosexual symbolism of the dressing-up games that young girls often play to imitate the grown-up image and identity of either their mothers or their media heroines. In one of these, a mother looks on as one of her young daughters paints her lips, while in another we see the same girl in a vampish, fancy-dress costume, with her younger sister sitting on the floor behind her and with her back towards us.[38] It is interesting to note, however, the way in which Williams has photographed the expression of the mother in the first image and that of her daughter in the second in soft focus. This stylistic device affords a disquieting aspect to the scenario and seems to connote that the child's identity is liminal, that she is, indeed, on the threshold of becoming an individuated personality and of casting aside her childhood innocence. The mother's gaze is one of concern but her expression also seems wistful, as if she realises that this is not just a game her daughter is playing, but the first stage in the development of an autonomous ego, a socialised body that will no longer be exclusively dependent on the maternal bond. And, while the photograph of the girl clearly shows that she still has the body of a child, her suffused countenance seems somewhat anxious and melancholic – she glances downward and the diaphanous material she is playing with, also photographed out of focus, seems more like a shroud which is about to envelop her childhood.

The psychoanalytic dimension of such photography is more explicitly evidenced in the phototherapeutic imagery of Anna Jauncey (figures 9 and 10). Her work and philosophy have been influenced by the example of Jo Spence and Rosy Martin who in 1986 began to collaborate in the production of photographs that explored the mechanics of memory and power in the construction of

gender and sexual identities. Modifying their roots in social photography somewhat, their intention was not to stick with a straightforward documentary style, but to stage manage and reconstruct deep-seated psychological traumas through a process of 'self-documentation' with photography. Picking up on the various techniques of association and role playing expounded by Austrian psychoanalyst Alice Miller, as well as theories of the gaze by Foucault and maternal identification by Winnicott, the process of phototherapy involves the participation of the sitter/subject who performs his/her trauma for the photographer/therapist and who takes directions from him/her, although it is the subject who ultimately controls the way in which he/she is represented.[39] In this way, phototherapy gives rise to the pictorialisation of subjective, and previously unrepresentable, states of mind which go beyond the traditional codes of the 'happy family' album and conventional concepts of selfhood. As Spence and Martin expressed it themselves:

> We believe that each of us has sets of personalised archetypal images 'in memory', images which have been produced through various photo practices . . . Such photos are surrounded by vast chains of connotations and buried memories. We need to dredge them up, reconstruct them, even reinvent them, so that they work in *our* interests, rather than remaining the mythologies of others as photographic archetypes.[40]

Spence's exploitation of phototherapy led her to confront and make sense of the pain of both physical and psychological loss. In 1982 she was diagnosed as having breast cancer and, after having a lumpectomy, she turned to phototherapy to help her grieve the mutilation of her body and to come to terms with her disillusionment

with orthodox medicine. In one of several undated images produced with the help of Dr Tim Sheard, for example, she is represented wearing a mask and a surgical gown which she uncompromisingly opens to reveal her disfigured, naked body daubed with the word 'monster'. This highly personal response to her maimed and dismembered body shatters the myth of what Foucault called the 'truth game' (the idea that there is a perfect individual inside all of us simply waiting to be let out) and, in so doing, Spence rehabilitates the disabled, polluted, ill body as a symbol of defiant power.[41] Furthermore, in a series of images that she produced in collaboration with David Roberts, entitled *Mother and Daughter Work* and *Father and Daughter Work* (1988), she used phototherapy to enable her to mourn for her dead parents and to renegotiate the denial of her working-class origins. Here we observe Spence re-enacting the ambivalent process of identifying with the imaginary ego or other, an idea theorised by Lacan in his essay concerning the mirror stage where he deploys the metaphor of reflection to symbolise the sense of displacement that occurs in the construction of the bodily ego or other. Lacan had suggested that one's specular image produces a sense of both jubilation and alienation, the former because what one sees in the mirror appears to be a cohesive, fully-formed body, and the latter because the same image implies a material lack in the actual body, which in comparison to its image appears to be shattered or haunted by the presence/absence of what it desires to be or to have: the other.[42] In this type of iconography, Spence seems to conflate the idea of the fully-formed, imaginary ego and that of the body in pieces (*le corps morcelé*) by representing herself as both subject and object, that is simultaneously both as herself and in the image of her respective parents. Thus she is symbolised as a naked woman/child with an introjected love for her dead parents, but one

who is also able to become a complete body by assuming, *a posteriori*, the image of the other(s) who are lost to her.[43]

A similar autobiographical and psychosexual point has been effected by Anna Jauncey in her series of double portraits entitled *Myself in the Picture – with my Grandmother* and *Myself in the Picture – with my Grandfather* produced in 1994. Jauncey had studied documentary photography at Gwent College between 1988 and 1991, but only began to develop an interest in using photography as a vehicle for objectifying her own identity after her father, whom she had not seen for more than twenty years, had died of cancer. After the divorce of her parents, she had been raised by her mother and grandparents, who are also dead, and she consequently entertained the hope that her father would replace the family she had lost. To help her overcome the sense of loss, Jauncey began to reconstitute her missing family history by recombining at will photographs from the family album. Eventually this led her to collage old portraits of deceased relatives and more contemporary self-portraits in which she mimicked the dress code and expression of the family member concerned – witness figures 9 and 10 where we see Jauncey alongside her grandmother and grandfather respectively.

As is the case with Spence's iconography of her relationships with her own mother and father, we see Jauncey re-enacting a one-to-one relationship with her grandparents that appears to disavow her sense of loss. Instead, in a symbolic act of personal identification or reabsorption, she figuratively attempts to become the other person: 'I am trying to make something that expresses how I feel about their loss, and the ambivalent relationships I had with all of them.'[44] Moreover, in reclaiming their identities on such a level and in the imbrication of their own image with that of dead family members, Spence and Jauncey appear both to embrace and resolve the

process of melancholia described by Freud in *The Ego and the Id* (1923). In this essay, Freud had argued that when a person is made to renounce an object of desire, the initial tendency is for that object to become internalised or introjected, rather than totally rejected, in a melancholic act of unresolved grief which transforms 'the character of the ego'.[45] Only by confronting death and loss in the painful process of grieving can we transcend such introjection and reclaim the ego. It is precisely in such terms that Spence framed her *Mother and Daughter Work*, contesting:

> I pay homage to the working-class mother of whom I was taught to be ashamed: now de-constructed, re-assembled, psychically re-integrated as part of my history. By externalising my fantasies of our shared histories, I am finally able to separate myself from her at the same time as valuing the parts of me that are structured through my experiences of her and my class. A personal elision of the psychic, the social, the economic and the aesthetic in a death ritual.[46]

Performing gender

The role-playing manifested in the work of Williams, Spence and Jauncey also resists the idea of sex and gender as natural or prediscursive phenomena. Williams, for example, suggests that femininity is something that is both learned through socialisation and ritual and acquired through dressing up, while Spence and Jauncey effect polymorphous gender identities in their psychological portraits, taking on the persona of their respective patriarchs. What we observe being embodied in such instances is the representation of sex and gender as forms of masquerade or performance. This theory

has been pivotal to several important feminist interventions that insist the formation of an individuated identity is always a matter of doing or carrying out various acts and that it is, therefore, pointless trying to uncover some stable or fixed feminine or masculine identity beneath such acts. In 1929, for example, Joan Rivière argued in her essay *Womanliness as Masquerade* that femininity was no more than a series of masks which women adopted to survive in a patriarchal world.[47] Through this strategy women appear to conform to society's expectation of the ideal feminine while at the same time exploiting masquerade to conceal their own masculine nature, using it to dupe men and wrest power from them.

More recently, Judith Butler has repudiated the idea that gender identities are simply embodied in appearances and the donning and discarding of an appropriate mask or look, to elaborate a more complex theory based on the idea of performativity. She underscores, therefore, the Lacanian idea that, for both men and women, the status of one's sexual identity is not just provisional but also prone to the perpetual threat of dissolution since it is constituted in nothing more than the reiterated performance of a series of culturally assigned or engendered speech and body acts:

This iterability implies that 'performance' is not a singular 'act' or event, but a ritualized production, a ritual reiterated under and through constraint, under and through the force of prohibition and taboo, with the threat of ostracism and even death controlling and compelling the shape of the production.[48]

It is in this way, for example, that a man is expected 'to be' an autocratic manager at work and a woman 'to be' his subservient housekeeper, both acts illustrating the function of performative gender roles to reinforce sexual and power differences in patriarchal

society. According to Butler, therefore, one's identity is something that is materialised in and through the ritual of a pre-ordained, gender performance, yet something whose status remains volatile precisely because the performance needs to be repeated in order to maintain authority. Thus gender is 'a complexity whose totality is permanently deferred . . . because gender is not a fact, the various acts of gender create the idea of gender, and without those acts, there would be no gender at all'.[49] Moreover, although Butler postulates that in the repeated performing of these acts we initially substantiate and conform to the paradigm of normative, gender identities which serve to authorise the hegemony of straight society, she also suggests that through performativity we may contest and sublate this ideal, negotiating different types of femininities and masculinities in the process. These metaphysical ideas constitute one of the most difficult but cogent challenges to how we understand and negotiate the meaning of gender in so far as they suggest that the concept of a stable, unitary subject is bogus and that the construction of one's individual identity in the real world is sedimented in a kind of ritualistic role-playing. But they also help to illuminate our understanding of how many photographers (and artists) have represented the body and such strategies have consequently been of relevance not just for straight photographers who have explored the performance of orthodox sexualities but also for those photographers, whether straight or gay, who have focused on marginalised sexual and gender identities.

One such is Rosy Martin, who along with Jo Spence has pioneered the use of phototherapy since 1983. Like Spence, Martin has deconstructed the internalisation of mother/daughter relationships, dressing up in her mother's clothes and imitating what she calls her mother's 'martyred smile' so as to re-enact the subjugation of women in the context of family life. More strategically,

Martin has focused on the evolution of her own persona as a lesbian, arguing:

> my own particular need to make sense of the world, as I experienced it, left me with no 'natural' to fall back upon, but rather a constant questioning, oscillating between theory and practice, and the imperative to deconstruct my own sexual formation.[50]

This led her to pose the fundamental question: 'What are lesbians supposed to look like anyway?' One response was the series of photographs entitled *Transforming the Suit* in which we see the photographer dressed up in various guises that portray the multiplicity of identities embraced by the lesbian persona. In one set, she portrays herself wearing a black tuxedo and smoking a cigar so as to reveal how persistent and incomplete the masculinised stereotyping of lesbians is – such iconography, for example, is redolent of *fin de siècle* caricatures of female emancipation and the *nouvelle femme* like those executed by Guillaume for *Gil Blas Illustré* in 1893.[51] In the series, Martin was able to parody patriarchal notions of alternative sexualities as well as to express her own equivocation in coming out, contending: 'I had to come to terms with the identity I'd been taught to despise, whilst continuing to love and desire her.'[52]

As discrimination against gay people in Britain mounted with the advent of HIV/AIDS during the early 1980s and the introduction of Clause 28 in 1988, a measure intended to outlaw homosexuality from discourse by giving local authorities the power to exclude any mention of it in the educational curriculum, the political purpose of Martin's project was strengthened. In figure 11, for example, a piece of phototherapy which she produced with the collaboration of Jo Spence in the role of photographer/therapist, we see Martin bound

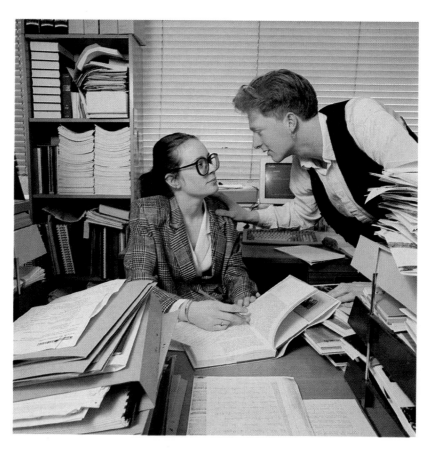

Figure 8: Karen Goss, *The Business Meeting*, 1993

Figure 9: Anna Jauncey, *Myself in the Picture – with my Grandmother*, 1994

Figure 10: Anna Jauncey, *Myself in the Picture – with my Grandfather*, 1994

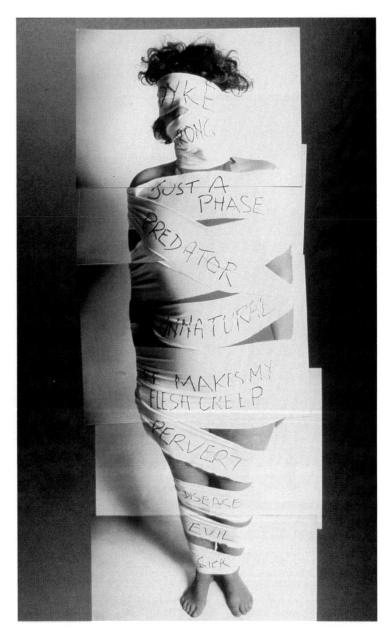

Figure 11: Rosy Martin (in collaboration with Jo Spence), *Unwind the Lies that Bind*, 1988

and gagged by bandages upon which are inscribed the pejorative terms of homophobia. Although on the surface it appears as if Martin has been silenced, here she defies the logic of Clause 28 by using language to make homosexuality visible and to undermine the bigotry that informs the passing of such legislation. As such she takes up the challenge of French feminist Monique Wittig, who called on women to step outside of the idea of sex as a coerced contract and to reclaim their inalienable right to be subjects rather than objects: 'The universal has been, and is continually, at every moment, appropriated by men . . . it is an act, a criminal act, perpetrated by one class against another.'[53] More particularly for Wittig it is language that will empower women. She called literature the 'perfect war machine' that would allow the 'other' to destroy the universal and unified heterosexual male subject and to impose or restore a new subject. The act of saying 'I', therefore, would proclaim this new subject and by using it women would learn to speak their way out of gender, an idea which Martin also exposes in a photo-portrait where she facetiously represents herself temporarily silenced by the plaster covering her mouth.[54] According to Wittig, the ultimate outcome of such a deconstructive strategy of empowerment would give rise to a multitude of voices and a plurality of sexes, 'For us there are, not one or two sexes, but many . . . as many sexes as there are individuals', and her ideal subject was the lesbian or gay man who, in transcending the binarism of normative categories of sex and gender, would inaugurate a radical revolution in the construction and meaning of identities.[55]

Debbie Humphry is another photographer who has attempted to represent homosexual men and women and transvestites both as subjects in their own right and as a paradigm for making us think about the construction of sex and gender in more fluid terms (figures 12–15). We have already encountered how Humphry has used

photodocumentary to explore the ways in which women have attempted to find a co-equal position in the hegemonic structures of the workplace (figures 2 and 3), but these images must now be reviewed in the context of her wider philosophy to represent individuals who are 'fighting their way out of the closet', by which she means those subjects, both straight and gay, whose sexuality trespasses

Figure 12 Debbie Humphry, *Gay Couple in Bedroom*, 1996

the normative and binding strictures of patriarchy.[56] In common with Rosy Martin, a large part of Humphry's agenda has been to challenge the inadequacies of sexual stereotyping and to encourage more enlightened attitudes towards the other, and it is worth quoting at length the objectives she has in mind to achieve this:

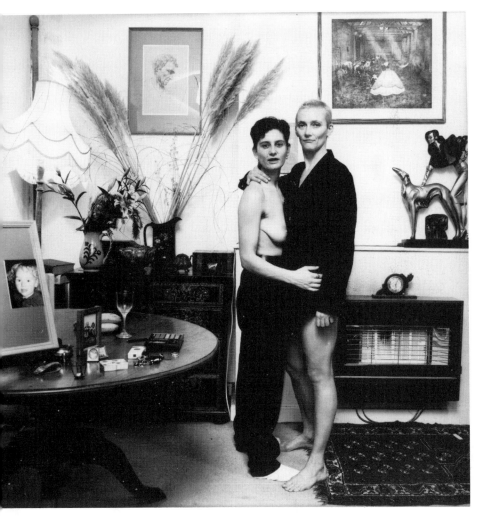

Figure 13 Debbie Humphry, *Lesbian Couple in Living Room*, 1996

People are photographed in a context broader than the gender interest – they are shown with friends, family, with interests and individual tastes. So there is the intention for them to appear as real, multi-faceted and accessible human beings not isolated, freak-like or glamorously superficial. This is a way of challenging prejudice by providing familiar contexts with increasing information

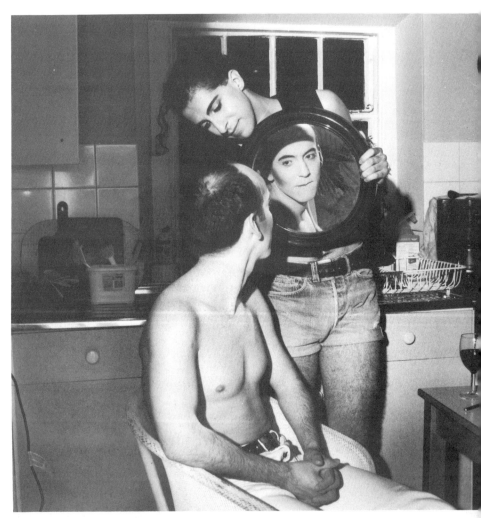

Figure 14 Debbie Humphry, *Drag Queen Getting Ready for his/her Performance*, 1996

– there is the opportunity for empathy. I do not want the audience to be voyeurs, I want them to cross a boundary from ignorance to understanding.[57]

In the wake of more provocative photographers like Diane Arbus and Nan Goldin (both of whom she appears to emulate in some of

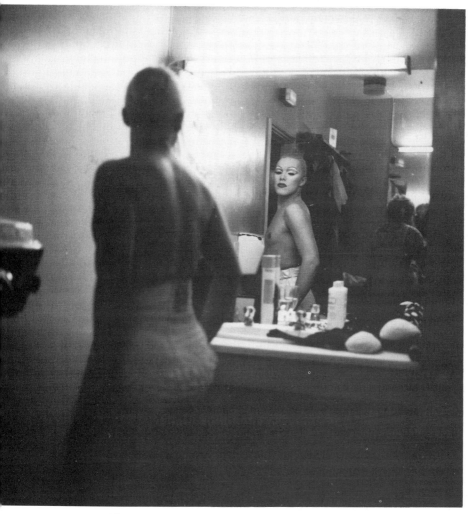

Figure 15 Debbie Humphry, *Drag Queen*, 1996

her images of transvestites and transsexuals), Humphry's vision might appear devoid of shock value; nevertheless, her work is not hackneyed or without political currency.[58] In figures 12 and 13, for example, the first representing a gay couple in their bedroom, and the second a lesbian couple in their living room, the men and women appear natural and literally 'at home' with their sexuality. These are not, to use Foucauldian terminology, merely 'docile bodies' that are either ready or willing to bow passively to the 'normalising judgement' of straight society.[59] By photographing them in their respective habitats and in close intimacy, her subjects look relaxed and strike poses that simultaneously assert pride in their homosexual identity as well as proclaiming their feelings towards one another. Borrowing a motif from Brassaï's image of two gay boys in a Paris bar respectively sharing the jacket and trousers of the same suit (c. 1932),[60] the lesbian couple perform a similar act and embrace each other as they gaze defiantly into the camera lens. The gay couple are likewise captured in a scene of self-assured sexual bonding, the one with arms wide open beckoning the other, who looks at us with a knowing, sideward glance and who seems to have an erection, into bed.

With the two studies of men in drag (figures 14 and 15), we also enter the territory of gender as performance. In contrast to the couples in the previous two photographs, however, their sexuality is more provisional and we confront the idea that physical features in themselves do not proclaim a clear-cut and unproblematic gender identity. Moreover, in keeping with Judith Butler, what Humphry's iconography appears to suggest is that sedimentation of gender identity is not merely realised in the act of dressing up, nor is it attained in a single or ephemeral performance, but it is accrued in the 'stylised repetition of acts': 'The effect of gender is produced through the stylization of the body and, hence, must be understood

as the mundane way in which bodily gestures, movements, and styles of various kinds constitute the illusion of an abiding gendered self.'[61] Inasmuch as Freud hypothesises that as children we learn to objectify ourselves as autonomous bodies free of maternal authority through the repetitive manipulation of the wooden spool in the *fort/da* (*here and there*) game (to which I refer in more detail below), Butler's thesis underscores in similar fashion the idea that it is the repetitive performance of acts and deeds that bolsters the illusion of stable, heterosexual masculine or feminine identities in conformity with the law of patriarchal society. It is worth emphasising here the idea that performativity produces only the illusion of a cohesive heterosexual identity for, as Butler contends:

> its power to establish what qualifies as 'being' . . . works not only through reiteration, but through exclusion as well. And in the case of bodies, those exclusions haunt signification as its abject borders or as that which is strictly foreclosed: the unlivable, the nonnarrativizable, the traumatic.[62]

Consequently, it can be argued that when we reiterate gendered acts oppositionally and against the grain, we effect not only a radical reorientation of our psychic personalities but one that also enables us to contest/transgress patriarchy by figuring ourselves as the abject or unliveable other.

We can observe this tension between incorporation and exclusion, between identificatory borders and excess, as well as some of the implications of what Butler calls stylistic repetition, being played out on different levels in figures 14 and 15 where the characters in drag have not just been represented as life's grotesques, but rather as individuals struggling to redefine, often against all physical and mental odds, the limits of their own psychosexuality. In figure 15, for

instance, the man/woman checking out his/her appearance in the mirror as he/she dresses for his/her performance looks secure and experienced in such an act of sexual metamorphosis. No matter how temporary the act or transformation may be, he/she seems to have learned the part of drag queen well and to assume it with ease. Figure 14, meanwhile, strikes a more poignant note in the way it represents the doubts and anxieties of a man in the act of being made up by another male. The diffident, bemused facial expression we see reflected in the mirror forms an arresting focal point in the photograph and appears to resist the specular crystallisation of the ego or of the *corps morcelé* that Lacan had argued the mirror image effects. As we regard 'he' in the process of becoming 'she', a crucial and universal dilemma of human consciousness immanent in the act of self-reflection, indeed of performing gender itself, also appears to be signified: 'Who am I?'

The manifestation of such a fluid and free-floating sexuality in these two images, therefore, symbolises the shattering or rupturing of the individuated male subject's identity, in such a way that appears to adumbrate the anxiety raised by Lacan in *The Mirror Stage* of regarding the ego as an alienated body, as both self and other. But the 'in-betweenism' of these subjects, I feel, also unsettles masculinity on another level for, at one and the same time, they make visible and feminise the phallus, which Lacan posits as the transcendental signifier of power relations between the sexes in the post-mirror phase. What Lacan had argued for in his essay *The Meaning of the Phallus* is the interdependence of sexual difference and the use of language (or the Symbolic) in the formation of a masculine or feminine identity.[63] In other words, he posited a version of psychosexuality based on linguistics or the law of the father, maintaining that once the child is separated from the maternal love object, having lost it to the father figure, he/she becomes both a

sexual and a social body who begins to symbolise and to compensate for the lost object of desire in language and other forms of representation. For Lacan (as for Freud before him) this Oedipal scenario sets up an economy of restraint and prohibition, organised around the threat of castration and the phallic signifier. It is the phallus, which he links to the father figure, that is the central or primary signifier for all forms of desires and repressions but one which also, in the individual's enacting of the law of the 'name of the father', remains veiled in the unconscious.[64] This phallogocentric economy implies a perpetual sense of incompleteness or searching for both male and female subjects since it postulates that the phallus is nothing more than a signifier, an entity without specific meaning in itself that can only open the way to a system of metaphors, a chain of arbitrary and unstable meanings. The power of the phallus, therefore, can be seen to be essentially bogus. But the implications of such powerlessness none the less are not the same for both sexes and the phallus establishes a particular dynamic or tension between them based on 'having' and 'lacking' which leads to the construction of masculinity as active and femininity as passive. Although the male subject by virtue of his body may be argued 'to have' a phallus, this is a misrecognition of the possession of power and he is, therefore, compelled to compensate for this lack in his domination of the other who appears less powerful still, that is woman. Within this context, woman is cast in the role of the already castrated object who appears to be no more than a passive victim and who can only attain some sense of recognition or obtain a phallus by symbolically 'being' a phallus – that is, by appearing to be that alienated love object which the man desires, an act she performs in masquerade.[65]

It is in such a phallogocentric economy, therefore, that heterosexual men strive to overcome their own vulnerable, split

subjectivity and to repress their own desire for the lost maternal by asserting their domination over women and emphasising their own impenetrability. In terms of representation and other modes of textual production, this means adopting the role of active agents, keeping themselves out of representation, while symbolising women as powerless objects of visual pleasure, of the male gaze. The 'dragging up' we witness in Humphry's photographs consequently works at the level of a double signification. Not only do these images bring something subliminal or unconscious to the surface as an object of the gaze – the desire of the male subject to recuperate the feminine (maternal) other – moreover they subvert and debase the essential sexual or gender difference between men and women by portraying that which challenges or haunts masculine identity, indeed what the name of the father demands should exceed representation: male subjects paradoxically in the process of becoming female objects, of 'being' a phallus through masquerade. Thus drag and the performativity of gender serve as tropes to cast doubt on and disavow the phallogocentric symbol of the hard, masculine body which, as Luce Irigaray writes, 'grants *precedence to solids*' by marginalising that which it deems 'soft', irrational or undesirable – that is, with regard to gender, women and homosexuals.[66]

Significant others: whose body is it anyway?

> I did not ask her name or her history . . . I knew that I had recorded the essence of my assignment.
>
> (Dorothea Lange, 'The Assignment I'll Never Forget: Migrant Mother', *Popular Photography*, February 1960)

40

One of the main accusations that has been levelled at photographers, and particularly at photodocumentarians, is the allegedly exploitative nature of their praxis. Indeed, the technical terminology of photography, as Roland Barthes and Susan Sontag have maintained, orbits around the lethal language of the murderer him/herself, and the camera becomes, therefore, the photographer's weapon.[67] Thus we speak of 'aiming' a camera, keeping a finger on the trigger of the lens, and 'shooting an image'. As Barthes succinctly expatiates: 'Life/Death: the paradigm is reduced to a simple click, the one separating the initial pose from the final print.'[68] Moreover, it has been argued that there is more often than not a huge material and class gulf between the empowered (bourgeois) producer and the powerless (working-class) subject and that consequently the latter is represented as if he/she were an alien species or the other. This discrepancy in power appears to be especially exacerbated during periods of historical crisis such as the Depression of the 1930s when photographers in Britain and America documented the plight of the unemployed and homeless.[69] Raymond Mortimer alludes to this situation, for example, in the preface to Bill Brandt's photo-essay The English at Home (1936), where he states: 'Mr. Brandt shows himself to be not only an artist but an anthropologist. He seems to have wandered about England with the detached curiosity of a man investigating the customs of some remote and unfamiliar tribe.'[70] In this section of the essay, I want to examine whether we can level such a criticism against the work of female practitioners and, indeed, to argue whether it is ever going to be feasible for any photographer to transcend the ostensible gulf in power between producer and subject.

Writing in 1921, the Marxist historian Georg Lukács set out to reveal how cultural production, even when it was intended to serve the interests of the working classes by appearing to give them a

voice or by making them visible, ultimately achieved nothing more than to reinforce the hegemonic class structure of the bourgeoisie and to lull the working classes into a sense of false consciousness.[71] He argued that in the spectatorial dynamics of such production the working classes were reified as if they were commodities that could be bought and sold, and that the proletariat would seize power only by turning the telescope around, as it were, to become the subject of its own gaze.[72] The discrepancy in power between the middle-class observer and the working-class observed that Lukács describes is made more acute in photographic production, which because of its denotative or iconic relationship to the real world and its imputed realism, implies a kind of double subjugation – that is, if the photograph simply represents things as they exist, it in turn occupies a tautological or pleonastic position with regard to reality by merely replicating the prevailing hegemonic view of the world. It is in this way that Pierre Bourdieu has contended:

> It is . . . not surprising that photography can appear to be the recording of the world most true to this (our) vision of the world . . . because the social use of photography makes a selection . . . structured according to the categories that organize the ordinary vision of the world.[73]

Let us examine these ideas concerning selection and hegemony with reference to some specific examples of images by female photographers. At the beginning of this essay Dorothea Lange was invoked as a useful paradigm of how women's photography can be framed and, by implication, demeaned in patriarchal discourse that emphasises the emotional and maternal aspects of such praxis. While I opposed this kind of interpretation of her work, however, we should not lose sight of the fact that any holistic analysis of the

photographs Lange produced during the 1930s must none the less address the extent to which her personal ideological motivation fitted in with the aims and objectives of the FSA by whom she was employed in an official capacity. As a government-sponsored photographer, Lange's work was prone to surveillance and censorship by Roy Stryker, director of the project, who with his avowed intention to assemble what he called a great collection of pictures, issued photographers with directional shooting scripts and edited out of the file 100,000 of the photographs submitted by punching holes in them.[74] But this kind of selection and control was not just something that occurred on high, and in several instances photographers were allowed to assert their own authorial control. Lange was one of these and, although committed to the veristic ideals of documentary photography and to historical accuracy, she not only insisted on keeping a file of her own pictures, but also openly revealed that her intention, like Stryker's, was to capture a good picture. It is highly ironic, for example, that Lange in producing *Migrant Mother*, one of five images she took of the same theme and probably the most iconic of all the FSA photographs, did not even bother to ascertain her subject's name or how she came to be in the predicament she was.

Clearly, such an approach appears on the surface not to do justice, either socially or politically, to the subject portrayed and underscores the potentially exploitative nature of much documentary expression, indeed of much photography *per se*. At the same time, however, I feel we should be wary of stating categorically that Lange's assignment diminishes her subject and of making sweeping generalisations concerning the ethics of her photographic production on the basis of one image. Rather more, what this example reveals is that, in framing our criticism of any photograph, we should also consider the more specific circumstances surrounding both its

production and circulation. Lange never tried to conceal her intentions in photographing the *Migrant Mother* and, even if she did not know the identity of the sitter, as Jack Hurley has suggested, in producing a series of images of the same woman and her children at the very least the photographer must have 'walked around the woman and her children in their lean-to tent, trying different angles and combinations'.[75] The point I feel we have to consider here, therefore, concerns the instrumentality of photography and the ways in which images are given a context. Lange states that she thought she had captured 'the essence' of her assignment, which we can interpret on two levels: on the one hand, that her intention was to make a good photograph, but, on the other, that she had produced an image she hoped would have some positive repercussions for her subject and others like her. In its own time, for instance, *Migrant Mother* was a high-profile and widely publicised photograph and many other of Lange's images were also reproduced in books, newspapers and the popular illustrated weeklies.[76] This visibility doesn't exactly rid the photograph of its class connotations, and in some ways it actually subtends such an attitude by underscoring the otherness of the subject in the eyes of the middle-class, urban, employed spectator.

But by exploiting the popular formal device of the look – the gaze of the *Migrant Mother*, who stares directly at us, is hard to evade – at the very least the photograph also kept the plight of the unemployed and the homeless in clear focus and challenged the potential indifference of its 1930s spectators.[77] In much the same way, therefore, we should tread carefully in contending that the anonymity of the subjects whom Debbie Humphry has photographed either infers that the photographer does not represent them meaningfully or respect what they stand for, or that as spectators this seriously detracts from our making sense of how she has objectified their

social and sexual identities. Thus it is too simplistic to claim, as Lukács did, that to represent people fairly and realistically producer and subject must always be either of the same class or, by extension, to assert that the distance between the producer and his/her subjects in terms of race and/or gender will make for images which are consequently less worthy of attention.

By the same token, we could also argue to what extent is the work of the photographer who lives with his/her subjects 'for a year, or two maybe', as Grierson postulated in his essay *First Principles of Documentary*, any more honest or committed than the photographer who doesn't?[78] An interesting case in point is the female Finnish photographer Sirkka-Liisa Konttinen, who between 1971 and 1982 documented the implications of urban renewal for the working-class community in Byker, a suburb of Newcastle upon Tyne.[79] Konttinen was a resident of the district herself, but none the less was painfully aware that she would still seem like an obtrusive, foreign photographer to the community among whom she lived. In constructing her photo-essay *Byker*, therefore, she aimed to rectify the perceived discrepancy in class and power between herself and the denizens she photographed by eschewing any moral criticism of them in the text that accompanied the images, and by giving them a voice of their own – Konttinen incorporated verbatim accounts from the past of the personal histories which the local residents had related to her. This exploitation of the subject's point of view enabled her to weave together past and present into a new, synchronic narrative, but the inclusion of the vernacular Geordie dialect and sense of humour also invests her project with an air of authenticity and veneration for her subjects. Indeed, the producer goes to some lengths to signal her own sense of isolation and the fact that she is the outsider from a strange land who would always be on the fringes of any real understanding of the community's lifestyle: 'An oddball, I

was hurled into a peculiar net of relationships, shortcutting into their friendship and unquestioned loyalty while pining to be a native on equal ground. Adopted again and again, with undeserved generosity, yet remaining outside and not belonging.'[80] Jacqueline Sarsby, similarly, has relied on the intertextuality of word and image to invert the usual power-play between photographer and subject. Exhibitions of her photographs of farming communities in Devon, for example, are always orchestrated by 'voiced captions' from the tape recordings of stories told by the subjects portrayed and, like Konttinen, she often uses stories from the past to illuminate present-day working conditions.

Another important element in the work of both of these photographers, as it is also for Jennette Williams and Debbie Humphry, is their reliance on *mise-en-scène* which enables them to represent subjects on their own terms by locating them in a context or a natural setting of their own choosing. What is at stake here is that in allowing the subject the freedom to choose his/her own environment, it is not just the photographer who reveals something of the material conditions of the subject's existence, but economic and social status are signified equally as much by the individual's choice of habitus in terms of dress, furnishings and other personal possessions. It is in this way, therefore, that social subjects, as Bourdieu maintains, 'distinguish themselves by the distinctions they make, between the beautiful and the ugly, the distinguished and the vulgar, in which their position in the objective classifications is expressed or betrayed'.[81]

A more particular concern in assessing the role of female photographers with regard to subject and object positions is the fact that women themselves, in terms of both production and representation, are usually objectified as the other. 'In relation to the gaze', writes Andrea Fisher, 'the position of women is, at the very

least, a duality: always simultaneously on both sides of the camera.'[82] The issue of authorship in the production of photographic images and the dynamics of looking at them as a gendered subject was given an interesting, post-modern twist when Sherry Levine began to plunder well-known photographs by male 'masters' Edward Weston and Walker Evans. Between the late 1970s and 1982, Levine rephotographed their work and thereby appropriated them as her own. Far from being a facile exercise in photographic simulation or felony, however, her intervention raised several important issues which the originals did not necessarily do, not least of which are the authority of the male producer and, in the case of Evans, *his* right to manipulate the subjects represented. Thus Levine rephotographed an image of the impoverished Gudger family dressed up in their best clothes, a picture that Evans and James Agee had omitted to reproduce in *Let Us Now Praise Famous Men* (1941) and, in so doing, she foregrounded an aspect of their history which Evans had kept hidden from view.

As we have already encountered, the complexities of production and spectatorship and the traduction of power between subject and object have also been of central concern to all of the women photographers included in this book who have adopted different techniques, styles and strategies in representing ideas about the other. Consequently, as I have argued, these practitioners have mobilised photography to challenge any simplistic belief in stereotypes and to undermine the binarism of patriarchal ideology by representing social, political and sexual identities as having a provisional or ambiguous status. For Rhonda Wilson, Karen Goss, Caroline Molloy and Jacqueline Sarsby this has involved focusing on issues concerning stereotyping, equality and power in the workplace, while for Debbie Humphry it has involved foregrounding individuals with polymorphous sexual identities that, paraphrasing Judith Butler,

'panic gender'[83] by suggesting there is no such thing as a stable, core, masculine or feminine essence. In contrast, Jo Spence, Rosy Martin and Anna Jauncey have exploited techniques of phototherapy and self-representation, objectifying themselves in the role of the other with the aim of symbolically portraying the emergence of an individuated identity. In this way, their work deals with the expression of psychosexual states, confronting feelings of introjection and the trauma of loss as well as feelings of self-hatred and abjection.

Conclusion

At this point it is worth taking stock of our argument to consider whether either the possibility of complete photographic objectivity or the opportunity for the transcendence of the other ever truly materialise, even in self-representation. Roland Barthes has raised several interesting points concerning the interpellation of subject and object positions in his seminal essay on the hermeneutics of the photographic image, *Camera Lucida* (1980), which I feel are both pertinent and useful for our assessment of women's photography. In this work Barthes speaks of all forms of photographic representation 'as the advent of myself as the other',[84] and contends 'I constitute myself in the process of "posing", I instantaneously make another body for myself, I transform myself in advance into an image. This transformation is an active one: I feel that the photograph creates my body or mortifies it, according to its caprice.'[85] The disavowal of a unified identity, which Barthes discusses here, in turn appears to align itself with the concept of sex and gender as masquerade or performance – in the same text, for example, he also draws a parallel between the theatre and photography in their mutual deployment of 'motionless and made-up faces'[86] – and his argument

infers, therefore, that in the act of being photographed we somehow become fluid, undone, neither subject nor object. Instead we are convulsed in an act of transubstantiation, our identity is suspended and we oscillate between two states as, 'a subject who feels he is becoming an object'.[87]

In dealing with questions of identity in such metaphysical terms, Barthes appears to put a Freudian spin on the nature of photographic likeness, on the one hand interpreting it as some sort of *fort/da*, the game in which, Freud argued, children play with the notion of disappearance and return, and, on the other, regarding it as a medium of death or transcendence.[88] However, in assessing the role of the other in photography, Barthes systematically eschews the blatantly chauvinistic theorising of Freudian Oedipal psychosexuality (he refers fleetingly to Freud on only two occasions in *Camera Lucida*, the first in discussing the womb-like security of landscape, and the second in affirming a positive role for the maternal feminine while inspecting images of his mother, in effect a stance that transgresses the normative, post-Oedipal masculine identity).[89] Indeed, the photographic *fort/da* that he elaborates in this context in no way parallels the active/passive gender polarity that underpins Freud's analysis of the male child's playing with a wooden reel tied to a piece of string. As Freud observed it, the game that the 'little master' played with this toy, throwing it away and retrieving it at will, served to disavow the castration anxiety he felt after being separated from his mother and enabled him to assert symbolically his control and domination over her.[90]

Conversely, Barthes' treatment of the idea of disappearance and return does not compound such patriarchal notions of binarism nor does it maintain the Lacanian idea of the unified specular or imaginary body. For, as he expresses it, photography turns us all, regardless of gender, race or class, into significant others.[91]

Moreover, in conflating subject and object positions, his theory has much to offer when we consider the work of women photographers in terms of both production and representation. For Barthes, as much as for the photographers whose work has been analysed in this essay, the *eidos* of all photography, whether self-representational or not, consequently lies in the way that it affords us the opportunity to explore identities in states of flux. In the final analysis, therefore, the work of female photographers as technically and iconographically diverse as Caroline Molloy and Jacqueline Sarsby, Jennette Williams and Debbie Humphry, can be seen to be united around a common political agenda that aims to deploy photography to subvert the tension or division between subject and object in the way that Barthes describes and to deconstruct the concept of sex and gender as bodily or naturally pre-given entities. As Monique Wittig has argued, while we are 'compelled in our bodies and in our minds to correspond, feature by feature, with the idea of nature that has been established for us', nevertheless we can only make sense of sex and gender within discourse; ' "men" and "women" are political categories, and not natural facts'.[92]

Notes

1. For a more general discussion of the role of women in photography since the nineteenth century see V. Williams, *Women Photographers, the Other Observers 1900 to the Present* (London: Virago, 1986) and N. Rosenblum, *A History of Women Photographers* (New York: Abbeville Press, 1994). M. Weaver, *Julia Margaret Cameron 1815–1879* (London: Herbert Press, 1984), meanwhile, provides an in-depth analysis of one of the most inventive female art photographers of the nineteenth century.
2. B. V. P. F. Heathcote, 'The Feminine Influence: Aspects of the Role of Women in the Evolution of Photography in the British

Isles', *History of Photography* 12(3), July/September 1988. For Wilding and Vivienne see Williams, *Women Photographers*, ch. 7.

3. The role of the female photographer had been subject to royal assent by Queen Victoria, herself a keen amateur photographer. Alexandra, Princess of Wales, had also attended the London Stereoscopic School, making it acceptable for women to pursue formal photographic training. See R. Taylor, 'Royal Patronage and Photography, 1839–1901', in F. Dimond and R. Taylor, *Crown and Camera: The Royal Family and Photography, 1842–1910* (London: Viking, 1987).

4. M. Durelle, *Women's Employment* (London, 1924).

5. Cited in *Just Before the War: Urban America 1935 to 1941 as Seen by Photographers of the FSA*, catalogue of the exhibition at the Newport Museum and the Library of Congress, October House, New York, 1968.

6. Lange cited in K. B. Ohrn, *Dorothea Lange and Documentary Expression* (Baton Rouge: Louisiana State University Press, 1980), p. 37.

7. P. Rabinowitz, *They Must be Represented – The Politics of Documentary* (London and New York: Verso, 1994), p. 7.

8. M. Foucault, 'Nietzsche, Genealogy, History', in D. F. Bouchard (ed.), *Language, Counter-Memory, Practice: Selected Essays and Interviews by Michel Foucault*, trans. D. F. Bouchard and S. Simon (Ithaca: Cornell University Press, 1977), p. 148.

9. See, for example, P. Jobling, 'Sirkka-Liisa Konttinen – The Meaning of Urban Culture in *Byker*', *History of Photography*, 17(3), Autumn 1993, pp. 253–63; and P. Jobling and D. Crowley, *Graphic Design – Reproduction and Representation since 1800* (Manchester: Manchester University Press, 1996), chs 6 and 7.

10. I am using the word 'queer' here to denote its current valency in referring to any producer or critic who, while not necessarily gay, aims to challenge and undermine patriarchal thinking by supporting polymorphous sexualities.

11. E. Kosofsky Sedgwick, '"Gosh, Boy George, You Must be Awfully Secure in Your Masculinity!"', in M. Berger, B. Wallis and S. Watson (eds), *Constructing Masculinity* (London and New York: Routledge, 1995), p. 12.

12. *Three Perspectives on Photography* (London: Arts Council of Great Britain, 1979).

13. J. Grierson, 'First Principle of Documentary', in F. Hardy (ed.), *Grierson on Documentary* (London: Collins, 1947), p. 84.
14. *Three Perspectives on Photography.*
15. R. Barthes, *The Photographic Message* (1961), in S. Sontag (ed.), *Barthes, Selected Writings* (London: Fontana, 1983), p. 196.
16. R. Barthes, 'Myth Today', in *Mythologies* (London: Paladin, 1972), p. 39.
17. R. Barthes, *Image Music Text*, for example, containing several important essays translated by Stephen Heath, was first published in paperback by Fontana, London, 1977.
18. J. Spence and J. Solomon (eds), *What Can a Woman Do with a Camera?* (London: Scarlet Press, 1995), p. 12.
19. See Williams, *Women Photographers*, ch. 2.
20. Ibid., ch. 3.
21. The Organization for Economic Co-operation and Development was set up in 1960 and participating countries include USA, UK, Canada and many countries in West Europe.
22. See R. Wilson, 'Pictures for Politics and Pleasure', *Ten.8* 26, 1987, pp. 2–13.
23. Hansard Society Commission, *Women at the Top* (London: Hansard Society for Parliamentary Government, 1990), p. 20.
24. See M. Mauss, 'Techniques of the Body', *Economy and Society* 2(1), 1973, pp. 73–5.
25. E. Wilson, *Adorned in Dreams – Fashion and Modernity* (London: Virago, 1985), p. 246.
26. The following provide interesting analyses of dress codes, including the wearing of trousers and suits, and their relationship to gender/sexual identities: C. B. Kidwell and V. Steele (eds), *Men and Women, Dressing the Part* (Washington: Smithsonian Institution Press, 1989); A. Hollander, *Sex and Suits* (New York: Knopf, 1994); L. Tickner, 'Women and Trousers', in *Leisure in the Twentieth Century* (London: Design Council, 1977).
27. V. Burgin, 'The Absence of Presence', in V. Burgin (ed.), *The End of Art Theory* (London: Macmillan, 1986), p. 41.
28. W. Feaver, 'Still Living for the Moment', interview with Henri Cartier-Bresson, *Observer Review*, 20 November 1994, p. 2.
29. See, for example, Martin Parr, *Home and Abroad* (London: Cape, 1995) and Chris Steele-Perkins, *The Pleasure Principle* (Manchester: Cornerhouse Books, 1990).

30. The captions include statements from *Computer Weekly* and Eric Webster's *How to Win the Business Battle*.

31. Karen Goss, personal statement lodged with *Iris: The Women's Photography Project*, Staffordshire University.

32. Xenophon, *Oeconomicus* VII, pp. 39–40, cited in M. Foucault, *The History of Sexuality*, Vol. 2 (Harmondsworth: Penguin Books, 1985), pp. 158–9.

33. 'Past and Present in Focus', *Farmer's Weekly*, 27 May 1994, pp. 6–7; 'Farm Women', *Light Reading*, May 1994, pp. 2–3.

34. R. Martin, 'Don't Say Cheese, Say Lesbian', in J. Fraser and T. Boffin (eds), *Stolen Glances: Lesbians Take Photographs* (London: Pandora, 1991), p. 94.

35. See Bouchard (ed.), *Language, Counter-Memory, Practice*; and M. Foucault, *Power/Knowledge, Selected Interviews and Other Writings 1972–77*, trans. C. Gordon (Brighton: Harvester Press, 1980).

36. Jennette Williams, personal statement lodged with *Iris: The Women's Photography Project*, Staffordshire University.

37. Ibid.

38. Although Williams is represented in the *Iris* project, it has not been possible to reproduce her work here because of copyright.

39. See J. Spence and R. Martin, 'Photo-Therapy: Psychic Realism as a Healing Art?', *Ten.8* 30, 1988, pp. 2–17.

40. R. Martin and J. Spence, 'New Portraits for Old: The Use of the Camera in Therapy', in R. Betterton (ed.), *Looking On: Images of Feminity in the Visual Arts and Media* (London: Pandora, 1987), p. 268.

41. L. H. Martin, H. Gutman and P. H. Hutton (eds), *Technologies of the Self: A Seminar with Michel Foucault* (Amherst: University of Massachusetts Press, 1988), p. 18.

42. For Lacan, the development of the ego is dependent on the infant body's identification with itself as an image, first glimpsed in reflection at around the age of six months and which leads to the alienated mirror-image, that is an internalised and fantasised imaginary construction of oneself which provides the 'threshold of a visible world'. See J. Lacan, 'The Mirror Stage' (1949), in A. Easthope and K. McGowan, *A Critical and Cultural Theory Reader* (Buckingham: Open University Press, 1992), pp. 71–6 and 243–4.

43. See J. Spence, 'Cultural Sniper', *Ten.8* 2(1), Spring 1991, pp. 8–25.

44. Anna Jauncey, personal statement lodged with *Iris: The Women's Photography Project*, Staffordshire University.

45. S. Freud, *The Ego and the Id* (1923), in J. Strachey (trans.), *The Standard Edition of the Complete Psychological Works*, Vol. 19 (London: Hogarth Press, 1961), pp. 1–66.

46. Spence, 'Cultural Sniper', p. 25.

47. J. Rivière, 'Womanliness as Masquerade', *International Journal of Psychoanalysis* 10, 1929, pp. 303–13. For a more recent, post-Lacanian femininist perspective on this idea see also Luce Irigaray, *This Sex Which is Not One*, trans. Catherine Porter (Ithaca: Cornell University Press, 1985). The whole area of psychoanalysis and gender is extremely complex and open to ongoing debate. For a good, contemporary round-up of various standpoints see R. Minsky (ed.), *Psychoanalysis and Gender, an Introductory Reader* (London and New York: Routledge, 1996).

48. J. Butler, *Bodies that Matter – on the Discursive Limits of 'Sex'* (London and New York: Routledge, 1993), p. 95.

49. J. Butler, *Gender Trouble – Feminism and the Subversion of Identity* (London and New York: Routledge, 1990), pp. 16 and 140.

50. Martin, 'Don't Say Cheese, Say Lesbian', p. 98.

51. See D. Silverman, *Art Nouveau in Fin-de-Siècle France – Politics, Psychology and Style* (Berkeley: University of California Press), 1988, ch. 4, for an intelligent assessment of the sexual politics of the 1890s.

52. Martin, 'Don't Say Cheese, Say Lesbian', p. 102.

53. M. Wittig, 'The Mark of Gender', *Feminist Issues* 5(2), Fall 1985, p. 4.

54. M. Wittig, *Les Guérillères* (1969), trans. D. LeVay (New York: Avon, 1973).

55. M. Wittig, 'Paradigm', in E. Marks and G. Stambolian (eds), *Homosexualities and French Literature: Cultural Contexts/Critical Texts* (Ithaca: Cornell University Press, 1979), p. 119. In empowering homosexual subjects in this way, Wittig both expands and provides a concrete example of Derrida's more transcendental, deconstructive concept of *différance*. See J. Derrida, *Speech and Phenomena and Other Essays on Husserl's Theory of Signs* (1967), trans. D. B. Allinson (Illinois: Northwestern University Press, 1973), p. 137 ('what is designated by "différance" is neither simply active, nor simply passive'); and J. Derrida, 'Choreographies', in C. McDonald

(ed.), *The Ear of the Other, Otobiography, Transference, Translation: Texts and Discussions with Jacques Derrida* (Lincoln: University of Nebraska Press, 1985), p. 184 ('I would like to believe in the multiplicity of sexually marked voices. I would like to believe in the masses, this interminable number of blended voices, this mobile of non-identified sexual marks whose choreography can carry, divide, multiply the body of each "individual" whether he be classified as "man" or "woman"').

56. Debbie Humphry, personal statement lodged with *Iris: The Women's Photography Project*, Staffordshire University.

57. Ibid.

58. See D. Emery-Hulick, 'Diane Arbus's Women and Transvestites', *History of Photography* 16(1), Spring 1992; and for Nan Goldin, C. S. Vance, 'Photography, Pornography and Sexual Politics', *Aperture* 121, 'The Body in Question', Fall 1990.

59. See M. Foucault, *Discipline and Punish: the Birth of the Prison* (1975), trans. A. Sheridan (New York: Pantheon, 1977), pp. 169 and 199.

60. Brassaï, *The Secret Paris of the 30's* (New York: Pantheon, 1976).

61. Butler, *Gender Trouble*, p. 140.

62. Butler, *Bodies that Matter*, p. 188.

63. Jacques Lacan, *The Meaning of the Phallus* (1958), in J. Lacan, *Écrits: A Selection*, trans. A. Sheridan (New York: Norton, 1977).

64. Ibid., p. 288 states that the phallus 'can only play its role when veiled . . . That is why the demon of . . . shame arises at the very moment when, in the ancient mysteries, the phallus is unveiled.'

65. Ibid., p. 280: 'it is in order to be the phallus . . . that a woman will reject an essential part of femininity, namely all her attributes in the masquerade'.

66. Irigaray, *This Sex Which is Not One*, p. 110. For a discussion of the psychosexual dynamics of the interrelationship between male bodies and ideas of hardness and domination, see both volumes of K. Theleweit, *Male Fantasies* (Minneapolis: University of Minnesota Press, 1987 and 1989), which include an analysis of the German Freikorps.

67. See R. Barthes, *Camera Lucida* (1980) (London: Flamingo, 1984); and S. Sontag, *On Photography* (Harmondsworth: Penguin Books, 1979), p. 14.

68. Barthes, *Camera Lucida*, p. 92. Sontag, *On Photography*, pp. 14–15, states that: 'there is something predatory in the act of taking a picture. To photograph people is to violate them, by seeing them as they never see themselves, by having knowledge of them they can never have; it turns people into objects that can be symbolically possessed. Just as the camera is a sublimation of the gun, to photograph someone is a sublimated murder – a soft murder, appropriate to a sad, frightened time.'

69. See B. W. Brannan and G. Fleischhauer, *Documenting America 1935–43* (Berkeley: University of California Press, 1988); and H. Spender, *Worktown People* (Bristol: Falling Water Press, 1982).

70. B. Brandt, *The English at Home* (London: Batsford, 1936), pp. 3–4.

71. G. Lukács, 'Reification and the Consciousness of the Proletariat' (1921), in *History and Class Consciousness*, trans. R. Livingstone (Massachusetts: MIT Press, 1968).

72. Ibid., p. 197. During the 1920s and 1930s, various worker photography movements were established in Europe and America. See, 'Left Photography Between the Wars: The International Worker Photographer Movement', in *Photography/Politics: One* (London: Photography Workshop, 1979), pp. 72–123.

73. P. Bourdieu, *Photography – A Middle-brow Art* (Cambridge and Oxford: Basil Blackwell, 1996), p. 77.

74. See L. W. Levine, 'The Historian and the Icon', in Brannan and Fleischhauer, *Documenting America 1935–43*, pp. 15–42; and A. Trachtenberg, 'From Image to Story', in Brannan and Fleischhauer, op. cit., pp. 43–73.

75. F. Jack Hurley, 'The Farm Security Administration File – In and Out of Focus', *History of Photography* 17(3), Autumn 1993, p. 247. In a similar vein, Paula Rabinowitz offers an insightful critique of the gender, class and racist connotations of the Depression photographs of Margaret Bourke-White, who was not employed by the FSA, in *They Must be Represented*, pp. 56–74.

76. See, for example, 'Look in Her Eyes!', *Midweek Pictorial*, 17 October 1936, which reproduces *Migrant Mother*, and 'Dust Bowl Farmer is New Pioneer', *Life*, 21 June 1937.

77. Roy Stryker, in R. E. Stryker and N. Wood, *In This Proud Land: America 1935-43 as Seen in the FSA Photographs* (Greenwich, CT: New York Graphic Society, 1973), p. 14, comments: 'The faces to me were the most significant part of the file. When a man is down and they have taken from him his job and his land and his home – everything he spent his life working for – he's going to have the expression of tragedy permanently on his face. But I have always believed that the American people have the ability to endure. And that is in those faces too.'

78. Hardy (ed.), *Grierson on Documentary*, p. 81.

79. For a fuller analysis of this work see Jobling, 'Sirkka-Liisa Konttinen'.

80. S. L. Konttinen, *Byker* (Newcastle upon Tyne: Bloodaxe Books, 1985), p. 125.

81. P. Bourdieu, *Distinction: A Social Critique of the Judgment of Taste*, trans. R. Nice (London: Routledge, 1994), p. 6.

82. A. Fisher, *Let Us Now Praise Famous Women – Women Photographers for the US Government 1935 to 1944* (London: Pandora, 1987), p. 136.

83. J. Butler, 'Melancholy Gender/Refused Identification', in Berger, Wallis and Watson (eds), *Constructing Masculinity*, p. 25.

84. Barthes, *Camera Lucida*, p. 12.

85. Ibid., pp. 10–11.

86. Ibid., p. 32.

87. Ibid., p. 14.

88. See S. Freud, 'Beyond the Pleasure Principle' (1920), in Strachey (trans.), *The Standard Edition*, Vol. 18 (1955), pp. 1–64. In this essay Freud discusses both the idea of repetition in the *fort/da* game, and the compulsion of the ego instincts, which he associated with the body, towards infirmity and death.

89. Barthes, *Camera Lucida*, pp. 40 and 74–5.

90. This is how Freud describes the *fort/da* game he observed: 'The child had a wooden reel with a piece of string tied round it . . . What he did was to hold the reel by the string and very skilfully throw it over the edge of his curtained cot, so that it disappeared into it . . . He then pulled the reel out of the cot again by the string and hailed its reappearance with a joyful "*da*" ["there"]. This, then, was the complete game – disappearance

and return' (see Strachey [trans.], *Standard Edition*, Vol. 18, p. 15). Freud went on to extrapolate that this behaviour was the child's way of compensating for the absence of his mother.

91. See also A. Jardine, *Gynesis: Configurations of Woman and Modernity* (Ithaca: Cornell University Press, 1985). Jardine argues that the pervasive nature of photography has turned man into an object and has consequently ruptured any sense of a unified subject, 'A new space, which was suddenly larger (or smaller) than Man, found a language, began to objectify Man, to turn him into an image' (p. 74).

92. M. Wittig, 'One is Not Born A Woman', *Feminist Issues* 1(2), Winter 1981, p. 17.

The Artists: Biographical Details

Anna Fox

Anna Fox currently lives and works in Aldershot. She studied
photography at West Surrey College of Art and Design (Farnham)
from 1983 to 1986. One of several photographers who have
transformed the grainy realism of the black and white
photodocumentary style, she tends to prefer chromatic work, often
using flashlit colour. In 1988 she published *Workstations*, based on
her exploration of office life in the south of England, with the help of
an Arts Council grant, and during the early 1990s she began to work
on *Friendly Fire*, a series of photographs exposing the make-believe
macho world of weekend war games. See A. Fox, *Workstations*
(London: Camerawork, 1988) and V. Williams, *Warworks: Women,
Photography and the Iconography of War* (London: Virago, 1994).

Karen Goss

Karen Goss was born in 1971 and currently lives and works in
Northumberland where she is studying for her MA in Fine Art at the
University of Northumbria. Since 1994, Goss has been involved in a
number of group shows beginning with *Who We Are – Women '94*
which was part of the *Signals* northern region exhibitions in
Newcastle. Her colour rotating pieces, of which *The Business
Meeting Came to a Disappointing Conclusion* is one, deal with
advertising and contemporary mass-media stereotypes of women.
Through the development of an alternative narrative structure, the
colour rotating pieces seek to dismantle common assumptions about

Debbie Humphry

Debbie Humphry was born in 1960 in Scarborough and now works as a freelance photographer in London. She received her BA in English Literature from Stirling University in 1982 and began working as a professional photographer in 1986. In addition to producing portraiture and documentary for clients as diverse as the BBC, the Terrence Higgins Trust and the *Observer* Magazine, Humphry teaches photography and is currently studying for a Masters degree in Gender and Society at Middlesex University. Her current work, *Gender Crossings*, is an on-going engagement with definitions of gender and sexuality in contemporary society as well as a negotiation with the traditions of photodocumentary. See M. Meskimmon, *Engendering the City: Women Artists and Urban Space* (London: Scarlet Press, 1997).

Anna Jauncey

Anna Jauncey was born in 1961 and currently lives and works in Cardiff. Jauncey received a BA in Psychology from Manchester Polytechnic (now Manchester Metropolitan University) in 1983, a Diploma and Certificate in Social Work from University College Cardiff in 1987 and an HND in Documentary Photography from Gwent College of Higher Education in 1990. The artist began her freelance photographic career with a host of voluntary-sector workshops and shows. Jauncey's more recent work draws on her diverse background using a documentary mode to explore themes of

family, memory, history and identity. Her works, including *Myself in the Picture – with my Grandmother and Myself in the Picture – with my Grandfather*, are more than straightforward documentation; rather, Jauncey's approach to her own family history is an intervention into the construction of women's roles and the conflicting demands placed upon them by society. Jauncey's work has often included installation and video as well as photographic portraits.

Sirkka-Liisa Konttinen

Sirkka-Liisa Konttinen was born in Finland but now lives and works in Newcastle upon Tyne. In the early 1970s, she studied film and photography at the Regent Street Polytechnic (now the University of Westminster) where she consolidated her interest in social documentary. Afterwards, she became a founding member of Amber Associates, a group of left-wing producers working on Tyneside whose central aim has been to forge 'a creative relationship with the working-class communities in the North-East'. Working with both still and moving images to elaborate the same theme or topic, she has made several books and films including *Byker* (1983); *Keeping Time* (1983) and *The Writing in the Sand* (1991). See *Amber/Side Catalogue and History of Work since 1968* (Newcastle upon Tyne: Tyneside Free Press, 1987) and P. Jobling, 'Sirkka-Liisa Konttinen – The Meaning of Urban Culture in *Byker*', *History of Photography* 17 (3), Autumn 1993, pp. 253–63.

Dorothea Lange

Dorothea Lange was born in 1895 in New Jersey and died in 1966 in California. Originally trained to be a teacher, Lange turned to

photography in 1917 and studied with Clarence White at Columbia University. During her lifetime she was successful both as a studio portrait photographer and as a documentarist, though it is as the latter that she is best known. Between 1934 and 1939, Lange was employed by the Roosevelt government, working first for the California Rural Rehabilitation Administration and then later for the Farm Securities Administration. Lange's works from this period, such as *Migrant Mother, Nipomo, CA* (1936) and *White Angel Breadline* (1933), have become synonymous with the American Depression years. See *Dorothea Lange Farm Security Administration Photographs, 1935–1939,* Vols I and II (Glencoe IL: Text-Fichte Press, 1980), and Karen Becker Ohrn, *Dorothea Lange and the Documentary Tradition* (Baton Rouge: Louisiana State University Press, 1980).

Rosy Martin

Rosy Martin was born in 1946 in London where she lives and works today. Beginning in 1983, in collaboration with the late Jo Spence, Martin pioneered the practice of 'phototherapy' and has since developed this mode of practice in ways which have enabled her to produce challenging forms of intervention into the construction of identity and the 'self'. Her work has tackled themes as diverse as lesbian politics, the family and, recently, the spaces of the city. Martin's work crosses boundaries between theory and practice to consider the political and psychic implications of representation. See her articles 'New Portraits for Old: The Use of the Camera in Therapy' (with Jo Spence), *Feminist Review* 19, March 1985, pp. 66–92; and anthologised in R. Betterton (ed.), *Looking On: Images of Femininity in the Visual Arts and Media* (London: Pandora,

1987); 'Don't Say Cheese, Say Lesbian', in J. Fraser and T. Boffin (eds), *Stolen Glances: Lesbians Take Photographs* (London: Pandora, 1991), pp. 94–105; and 'Home Truths? Phototherapy, Memory and Identity', *Artpaper* (St Paul, MN), March 1993, pp. 7–9.

Caroline Molloy

Caroline Molloy lives and works in London. She received her BA in Design from Staffordshire Polytechnic (now Staffordshire University) in 1990, followed by her MA from the Royal College of Art in 1994. Molloy has travelled and exhibited widely, including participating in various *Signals* shows in 1994 and 1996, and is represented in collections in Britain and France. Since 1994, she has worked as a freelance photographer for clients such as the *Sunday Times* and *Time Out.* Molloy's work is centred upon the exploration of identity and draws on her diverse experiences of other cultures and people encountered on her travels.

Katherine O'Connor

Katherine O'Connor currently lives and works in County Kerry, Ireland, having moved from New York where she received her BA in Photography at the School of Visual Arts in 1989. O'Connor has taught photography in both the United States and Ireland as well as showing work in numerous exhibitions in both countries. Her work, such as *Pleasures and Terrors of Domestic Comfort* (1991), concerns the documentation of the family but refutes any sense of the domestic sphere being a timeless or eternal entity. O'Connor gained inspiration for this theme from her first trip to her father's

hometown in Ireland in 1989 and has continued to produce material to do with south-west Ireland since then. See her writings *Pleasures and Terrors of Domestic Comfort* (New York: Museum of Modern Art, 1991), p. 91; *Live/Work in Queens* (Flushing, NY: Queens Museum of Art, 1995), pp. 7–8, 20–21; and 'The Land of My Father', *Irish America Magazine*, 1995, pp. 23–6.

Jacqueline Sarsby

Jacqueline Sarsby currently works as a freelance photographer/writer in Gloucestershire. Having first studied French, Sarsby went on to study Social Anthropology at postgraduate level and received her doctorate from the University of London in 1974. For ten years from 1977, Sarsby was a university lecturer, researcher and writer, becoming the first Director of the Women's Studies Diploma and the founder of the Oral History Research Group at the University of Kent. In 1987, Sarsby became a freelance photographer. The bulk of her work is concerned with the interaction between photography and oral history, documenting the lives of women in marginal communities, such as the potteries, mining villages and Devonshire farms. Sarsby has written and delivered numerous papers on her practice: see 'Farm Women', *Light Reading* 12, May 1994; and 'Past and Present in Focus', *Farmer's Weekly*, 27 May 1994.

Jo Spence

Jo Spence was born in 1934 in East Woodford, Essex, and died in 1992 in London. In the 1970s, Spence co-founded the Photography Workshop (with Terry Dennet) through which projects such as the

socialist feminist Hackney Flashers group began. In 1982, Spence received her BA in Film and Photographic Arts from the Polytechnic of Central London (now the University of Westminster); her work at this point focused upon women, work and the domestic sphere. In 1982, Spence was diagnosed with cancer. From this point, her work moved toward themes of personal identity, and with Rosy Martin, Spence pioneered the techniques of phototherapy. She wrote and exhibited extensively in the last decade of her life and has become a major influence upon a whole generation of British women photographers. Her major writings are collected in the anthology *Cultural Sniping: The Art of Transgression* (London: Routledge, 1995).

Jennette Williams

Jennette Williams lives and works in New York City. She graduated from the New York Law School in 1981 and received her MFA (Masters in Fine Art, specialising in photography) from the Yale University School of Art in 1991. Williams has worked as a visiting artist and lecturer in both New York and Connecticut as well as showing work in numerous locations in the United States. She first took up photography when she and her partner adopted a daughter. Having examined the use of photography in this highly personal way, Williams began to produce work which centred upon the ways in which anecdotal, familial and domestic scenes could act as a means through which to explore wider issues of childhood and identity.

Rhonda Wilson

Rhonda Wilson was born in Birmingham in 1953, received her MA in Photographic Studies from Derbyshire College in 1989 and currently

lives and works in Birmingham. She has been a partner in *Poseurs – The Image Authority*, a photographic studio and gallery, since 1989 and an associate lecturer in photography at Nottingham Trent University since 1992. Wilson has both produced and curated/researched exhibitions and poster campaigns concentrating on women's experiences of home and work for patrons as diverse as Birmingham City Council and the National Museum of Photography, Film and Television in Bradford. The *Worth Paying For* series was developed as part of her work for Birmingham City Council on the issue of women and low pay in 1987. In this series, Wilson challenged the traditional photodocumentary mode which rendered people in crisis as victims and moved towards a satirical form of 'advertisement' where the words of the women themselves could be interspliced with the images.

Note on the author

Paul Jobling teaches the history of graphic design and photography at Staffordshire University and Kingston University. Between 1989 and 1991 he edited the award-winning photojournal *Vue* and has published articles and reviews on pleasure and advertising, photojournalism and the photo-essay, and caricature in the nineteenth century. He is co-author with David Crowley of *Graphic Design: Reproduction and Representation Since 1800* (Manchester: Manchester University Press, 1996), a theoretical and historical study of printed media such as posters, advertisements, periodicals and printed ephemera, and is currently writing a book for Berg called *Bodylines – Pleasure, Power and Gender in Fashion Photography since 1970*.

Suggestions for Further Reading

Artworker Books, *Blood, Sweat and Tears – Photographs from the Great Miners' Strike 1984–85* (London: Artworker Books, 1985).

Barthes, R. *Camera Lucida* (1980) (London: Flamingo, 1984).

Bazin, A. 'The Ontology of the Photographic Image', *What is Cinema?*, Vol. 2 (California: University of California Press, 1971).

Bolton, R. (ed.) *The Contest of Meaning: Critical Histories in Photography* (Massachusetts and London: MIT Press, 1989).

Braden, S. *Committing Photography* (London: Pluto Press, 1983).

Burgin, V. (ed.) *Thinking Photography* (London: Macmillan, 1982).

Butler, S. *Shifting Focus: International Women's Photography* (Aruolfini, Bristol: Travelling Light, 1989).

Ewald, W. *Portraits and Dreams: Photography and Stories by Children of the Appalachians* (London: Readers and Writers, 1985).

FAN, 3(2), 1989, special issue on women's photography.

Fisher, A. *Let Us Now Praise Famous Women – Women Photographers for the US Government 1935 to 1944* (London: Pandora, 1981).

Fox, A. *Workstations* (London: Camerawork, 1988).

Goldin, N. and Armstrong, D. *A Double Life* (New York: Scalo/DAP, 1994).

Grundberg, A. *Crisis of the Real; Writings on Photography, 1974–1989* (New York: Aperture, 1990).

Hardy, F. (ed.) *Grierson on Documentary* (London: Collins, 1947).

Honey, N. *Woman to Woman* (Bath: Hexagon Editions, 1990),

Jobling, P. 'Sirkka-Liisa Konttinen – The Meaning of Urban Culture in Byker', *History of Photography* 17(3), Autumn 1993.

Jobling, P. and Crowley, D. *Graphic Design – Reproduction and Representation since 1800* (Manchester: Manchester University Press, 1996).

Knorr, K. *Marks of Distinction* (London: Thames and Hudson, 1991).

Konttinen, S. L. *Byker* (Newcastle upon Tyne: Bloodaxe Books, 1985).

——*Keeping Time* (Newcastle upon Tyne: Bloodaxe Books, 1988).

Lange, D. *Dorothea Lange Looks At the American Country Woman* (Fort Worth: Amon Carter Museum; and Los Angeles: Ward Ritchie Press, 1967).

Mann, S. *Immediate Family* (London: Phaidon, 1992).

——*Still Time* (New York: Aperture, 1994).

Martin, R. 'Don't Say Cheese, Say Lesbian', in J. Fraser and T. Boffin (eds) *Stolen Glances – Lesbians Take Photographs* (London: Pandora, 1991).

Martin, R. and Spence, J. 'What Do Lesbians Look Like?', *Ten.8* 25, June 1987.

——'Photo-Therapy: Psychic Realism as a Healing Art?', *Ten.8* 30, October 1988.

——'New Portraits for Old: The Use of the Camera in Therapy', in R. Betterton (ed.) *Looking On: Images of Femininity in the Visual Arts and Media* (London: Pandora, 1987).

Mayes, S. and Stein, L. *Positive Lives, Responses to HIV – a Photodocumentary* (London: Cassell, 1993).

Meskimmon, M. *Engendering the City: Women and Urban Space* (London: Scarlet Press, 1997).

Ohrn, K. B. *Dorothea Lange and Documentary Expression* (Baton Rouge: Louisiana State University Press, 1980).

Page, R., Prince, B. and Young, I. *Striking Women: Communities and Coal* (London: Pluto Press, 1988).

Rabinowitz, P. *They Must be Represented – the Politics of Documentary* (London and New York: Verso, 1994).

Rosenblum, N. *A History of Women Photographers* (New York: Abbeville Press, 1994).

Solomon-Godeau, A. *Photography at the Dock; Essays on Photographic History, Institutions, and Practices* (Minneapolis: University of Minnesota Press, 1991).

Sontag, S. *On Photography* (Harmondsworth: Penguin Books, 1977).

Spence, J. *Putting Myself in the Picture* (London: Camden Press, 1986).

——'Cultural Sniper', *Ten.8* 2(1), Spring 1991.

——*Cultural Sniping: The Art of Transgression* (London: Routledge, 1995).

Spence, J. and Solomon, J. (eds) *What Can a Woman Do with a Camera?* (London: Scarlet Press, 1995).

Williams, V. *Women Photographers, the Other Observers 1900 to the Present* (London: Virago, 1986).

——'Women in Photography – Archives and Resources', *History of Photography* 18(3), Autumn 1994.

——*Warworks: Women, Photography and the Iconography of War* (London: Virago, 1994).

Wilson, R. 'Pictures for Politics and Pleasure', *Ten.8* 26, 1987.

Also available from Scarlet Press

Nexus Volume 1
Engendering the City: Women Artists and Urban Space
Marsha Meskimmon

Engendering the City: Women Artists and Urban Space is the first volume of the **Nexus** series, and develops ideas from the exhibition 'City Limits' held at Staffordshire University in September 1996. Ten photographers were included in the show: Michelle Henning, Debbie Humphry, Karen Ingham, Bjanka Kadic, Rosy Martin, Alexandra McGlynn, Esther Sayers, Magda Segal, Emmanuelle Waeckerle and Elizabeth Williams. They all explore the theme of the city both as an actual physical location and as a central organising metaphor for social interaction. The types of work produced vary from 'new documentary' to interactive multi-media and installation. *Engendering the City* examines the ways in which these artists have negotiated with the powerful forms of modernism, the significance of gendered boundaries in urban environments, the sense of community links, and the concept of the spectator or pedestrian. Feminist reconceptions of space are combined with innovative representational strategies which reveal the many ways in which women artists can provide new models of seeing and knowing.

6 colour/14 b/w plates
ISBN Paperback 1 85727 098 3